The Campus History Series

STANTON

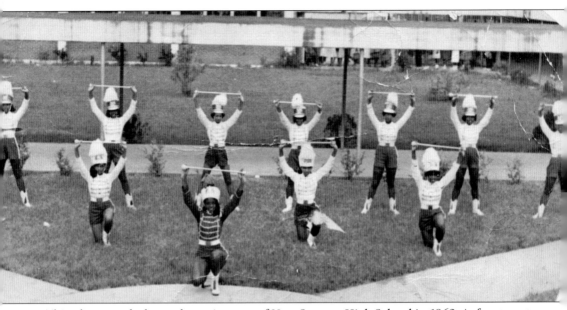

This photograph shows the majorettes of New Stanton High School in 1962. At front center is the head majorette at the time, Grace Brown (Galvin), this book's first author, who held the distinction of serving as head majorette two consecutive years, as it was traditionally a position held only by seniors. (Courtesy of the Stanton Cultural Heritage Committee.)

ON THE COVER: Taken in 1957, this image shows students walking in front of the New Stanton Building on Thirteenth Street. The image in the background is of the 1961–1962 Stanton Marching and Concert Band. (Courtesy of the Stanton Cultural Heritage Committee).

The Campus History Series

STANTON

GRACE BROWN GALVIN, TIFFANY GALVIN GREEN, PH.D.,
AND RONALD E. GALVIN

ARCADIA
PUBLISHING

Published by Arcadia Publishing
Charleston SC, Chicago IL, Portsmouth NH, San Francisco CA

Printed in the United States of America

Library of Congress Catalog Card Number: 2008940764

For all general information contact Arcadia Publishing at:
Telephone 843-853-2070
Fax 843-853-0044
E-mail sales@arcadiapublishing.com
For customer service and orders:
Toll-Free 1-888-313-2665

Visit us on the Internet at www.arcadiapublishing.com

This book is dedicated to all of the past, current, and future students, teachers, family members, friends, and community people who care about Stanton and continue to show their love, pride, and support to the school and to us!

CONTENTS

ACKNOWLEDGMENTS

This pictorial history attempts to summarize some of Stanton's rich history over a period of 140 years. With such a "grand" goal, we must first acknowledge that we could not include everything and that these images are intended to be representations of various persons, events, and locations through the years. We are aware there is much more to the history than that which is seen here, and we hope readers will understand that we did not mean to intentionally leave anything or anyone out. It is our hope that this is a foundational "living document" of our school's history—groundwork for others to build upon in the years to come.

All images appearing in this book, unless otherwise noted, appear courtesy of the Cultural Heritage Committee of Stanton College Preparatory School, of which the first author, Grace Galvin, is the founder and chairperson. Through the eight-plus years of its existence, several artifacts, pictures, news clippings, stories, and, most importantly, yearbooks have been collected. It was this collection of materials that served as the motivation for this project. Thus, first and foremost, we want to express our sincere thanks to all of the students, alumni, faculty, administrators, staff, friends, family members, and various community leaders for their assistance through the years in helping us locate and accumulate the materials that have enabled us to put this book together. The support has been overwhelming, and there are just too many people to name.

From the beginning, the work of the Cultural Heritage Committee was facilitated by the tireless efforts of Diana Tall, who is no longer with us, but whose memory we honor in the completion of this book. Evelyn Norris and Ty Rogers have also contributed an enormous amount of energy and assistance through the years. The gathering of additional materials was aided by contributions by those mentioned within the book, as well as "footwork" done by Robert L. Williams, Joe and Nellie Henry, and Solomon Oliver. Current students from the yearbook staff helped us get things off the ground after Arcadia accepted the book proposal, particularly George Oehl and Shayla Bivins, while the current staff, faculty, and administration have shown overwhelming support in whatever requests were made, specifically Principal Debra Lynch and Assistant Principal Norma Hayward. Finally, we wish to thank Luke Cunningham, Lindsay Harris, Maggie Bullwinkel, and all the other staff members of Arcadia Publishing for their interest and support in this project.

INTRODUCTION

For over 140 years, the name Stanton has been synonymous with a dedication to scholastic achievement, as well as a commitment to community and family. Over the years, Stanton, an academically renowned high school located in Jacksonville, Florida, has remained a beacon of light among the citizens of Jacksonville, particularly the African American community. This book is a living document that will expand over time, as it is a pictorial representation of the vitality and presence of this institution in Florida's history throughout the years.

Stanton is the oldest continually operating high school in Florida. It was built in the 1860s before being destroyed, rebuilt, destroyed again, rebuilt again, moved, and changed from comprehensive to vocational to college preparatory curricula. The school at one time taught all grade levels before permanently becoming a senior high school in the late 1930s. The school has existed under several names, including Stanton Normal School, the Stanton School, the Stanton Institute, Old Stanton High School, New Stanton High School, Stanton Senior High School, Stanton Vocational High School, and its current form, Stanton College Preparatory School.

The school emerged in the years following emancipation, when a group of African Americans from Jacksonville organized the Education Society and, in 1868, purchased the property on which the Old Stanton school now resides. In December of that year, a wooden structure was built and incorporated through the aid of the Freedman's Bureau and named in honor of Edwin McMasters Stanton, Pres. Abraham Lincoln's Secretary of War. Stanton was the first school of education for African American children in Jacksonville and its surrounding counties and it was the first school for African American children in the state of Florida. The first building was destroyed by fire in 1882. Another building constructed the same year was also destroyed by fire on May 3, 1901, in a fire that destroyed much of Jacksonville. A new school was constructed in 1902 and remained in operation until 1917.

The deteriorating and unsafe condition of the poorly constructed school building in the 1910s prompted the Stanton School trustees and interested citizens of Jacksonville to demand a new structure from the Board of Public Instruction. After the building was declared a fire hazard and unsafe for the 1,200 students who were schooled there on a daily basis, an agreement was finally reached where the board agreed to replace the wooden structure with a good fireproof building. In 1917, the building, which stands at Ashley, Broad, Beaver, and Clay Streets, was completed with modern equipment and facilities for its day. This structure was termed the "New Stanton" of its time, in fact.

An equally impressive record of academic expansion has been accomplished with the physical growth of Stanton. Beginning as an elementary school with six grades under the administration of J. C. Waters as the first principal and D. W. Gulp, who followed as principal, Stanton gradually became known throughout the state for the high educational standards, which it still maintains today. The eighth grade was added under the principalship of W. M. Artrell. Principal James Weldon Johnson started the move toward a high school department. The addition of the 12th grade made Stanton an elementary, junior, and senior high school.

Stanton continued as a school for all grades through the administration of I. A. Blocker, G. M. Sampson, and J. N. Wilson. In the 1940s, with F. J. Anderson as principal, Stanton eventually became a senior high school exclusively. During this time, Stanton served more than 1,100 students in its 23 classrooms.

In 1953, the Stanton name was transferred to a new facility in the LaVilla area (on Thirteenth Street) and was renamed New Stanton Senior High School. Charles D. Brooks was the first principal of the "new" school. Under his leadership, Stanton continued to foster the same traditionally high standards as it had always ascribed to, becoming the oldest and most important high school for African Americans in Jacksonville. Beginning in 1953, the Board and Ashley Streets facility became known as "Old" Stanton, becoming a junior high school for a short time before being converted into Stanton Vocational High School, which focused on a vocational training curriculum for secondary students, adults, and veterans in both day and night programs.

From 1969 to 1971, the focus of New Stanton Senior High School also began to change from academic to vocational under the principalship of Ben Durham, the former principal of Stanton Vocational High School. In 1971, the Old Stanton High School building (Stanton Vocational High School) was again placed under control of the trustees of Stanton and the student body was transferred to New Stanton Senior High School to become Stanton Senior High School, where the revised curriculum now provided for both the academic and the vocational interests of the students. It operated as Stanton Senior High until the early 1980s when it became Stanton College Preparatory School.

In 1981, Stanton College Preparatory School became the Duval County School System's first magnet school. It began with grades 7–10 and added one grade level each succeeding year; the first senior class of 54 students graduated in 1984. Carol Walker was its first principal. Stanton College Preparatory School now serves high school students living within the 841 square miles of the Duval County School District and leads the Duval County Public Schools in academic achievement.

Stanton now reaches toward the future. Stanton strives to identify promising students, raise their aspirations, and support their efforts to do well in school and prepare for college. Administrators, teachers, parents, and students work together to set goals and implement programs to enhance the learning atmosphere at Stanton. The instructional staff of professional educators has the ability to foster genuine creativity; teachers concentrate on inspiring, coaching, guiding, and motivating students. The mission of Stanton College Preparatory School is to provide a highly advanced academic program for students in grades 9–12 with an average enrollment of over 1,500 students. The course offerings include only honors-level, Advanced Placement (AP), dual enrollment, and International Baccalaureate (IB) classes. Stanton consistently ranks first in the county and in the top three in the state for the number of National Merit semifinalists. *U.S. News and World Report* ranked Stanton at ninth place on its 2008 list of America's Best High Schools. It has frequently ranked first in the United States in the number of International Baccalaureate diplomas awarded.

Finally, the extraordinary level of the alumni support and activity for Stanton is a part of its truly amazing history of pride, excellence, and tradition. Although there is no "formal" alumni association, there are several organized groups (representative of graduating class years), as well as the school's Cultural Heritage Committee. The Stanton Cultural Heritage Committee's goal is to gather, preserve, and celebrate the history of Stanton. The committee was organized in 2001 to encourage all attendees of Stanton to share their experiences as a living "historical" record of the school. Annual events are sponsored by various class years, the school, and most notably the Cultural Heritage Committee—altogether these events have brought together more than 2,500–3,000 active alumni from the 1920s to the present. Currently, graduating class members from the past two decades also sponsor various e-forums for contacting each other and scheduling reunions. There are also reunion tours conducted yearly during the summer months. Stanton has an amazingly strong legacy that continues to thrive!

One

PLACES WHERE STUDENTS LEARNED
CAMPUS AND BUILDINGS

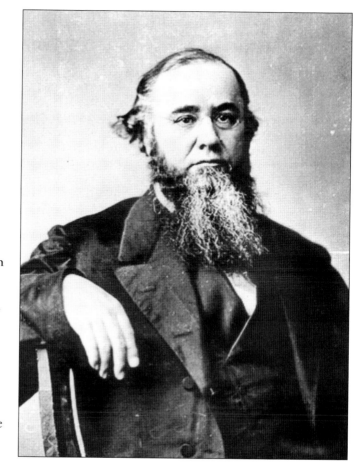

The Stanton School was named in honor of Gen. Edwin McMasters Stanton, who was an ardent champion of human rights and an advocate of free formal education for African American children. General Stanton was a lawyer, politician, U.S. Attorney General in 1860–1861, and Secretary of War under Pres. Abraham Lincoln and through most of the American Civil War and Reconstruction era. He began his political life as an antislavery Democrat.

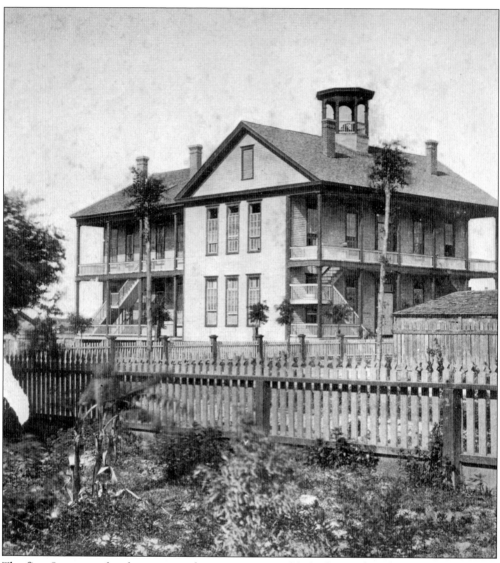

The first Stanton school was a wooden structure established in 1868. After emancipation, a group of African Americans in Jacksonville organized themselves into the Education Society, who envisioned opening a school in order to give their children the education they so richly deserved. The Education Society pooled together enough money to purchase a small lot of land on the corner of Ashley and Broad Streets. On February 8, 1868, the Education Society purchased the property on which the Stanton School building now stands from Ossian B. Hart and his wife. This property was covered by warranty deed to C. F. Chase, I. L. F. Garvin, and Edwin M. Randall, trustees of the Florida Institute, for the purchase price of $850. It was their purpose and intent to erect on the property a school building to be known as the Florida Institute. Financial problems, however, delayed progress on the building until December of that year. (Courtesy of State Archives of Florida.)

The first school was built and incorporated through the aid of the Freedman's Bureau, a division of the U.S. War Department. For many years, the Freedman's Bureau conducted the school, employing Northern white teachers until the county finally leased the property for the sole purpose of having a public school, also termed a "Free School therein for Black children." (Courtesy of State Archives of Florida.)

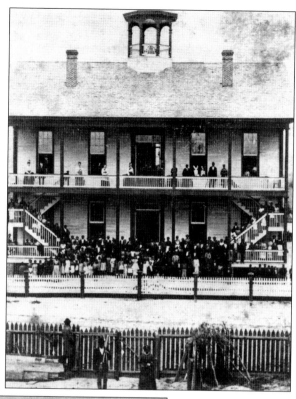

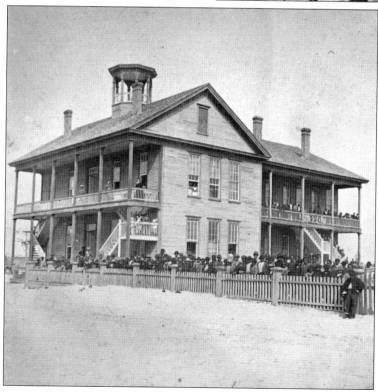

Pictured here in the 1880s, the Stanton School, sometimes referred to as the Stanton Institute, provided a grammar school education and had been incorporated into the Duval County Schools in 1870. Among the pupils shown here in front of the building may have been James Weldon Johnson and John Rosamond Johnson, whose mother, Helen Dillet Johnson, taught at the school during this time. (Courtesy of State Archives of Florida.)

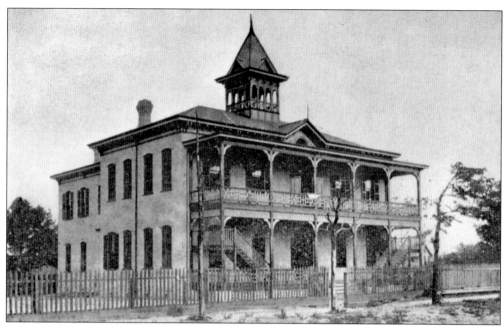

The first Stanton building was destroyed by fire in 1882. The building pictured above was constructed the same year. Unfortunately, it was also destroyed by fire on May 3, 1901, in a fire that destroyed much of Jacksonville. During this period, James Weldon Johnson served as principal of the school for nearly eight years, expanding the school from 8 to 12 grades, making it the only high school for African Americans in Jacksonville. At this time, the school had the largest enrollment of any school for African Americans or whites in Duval County and possibly Florida. A new school was constructed in 1902 (pictured below) and remained in operation until 1917. On May 23, 1914, the Circuit Court of Duval County appointed nine African American trustees to manage the school and its property—R. C. Archibald, S. H. Hart, A. L. Lewis, J. W. Floyd, W. I. Girardeau, I. L. Purcell, B. C. Vanderhorst, J. E. Spearing, and W. H. H. Styles. Archibald and Hart resigned and were replaced by J. M. Baker and L. H. Myers. (Both courtesy of State Archives of Florida.)

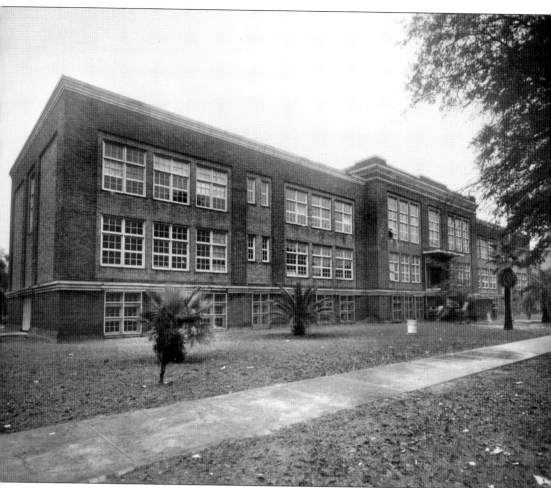

Starting in 1914, the Stanton School trustees and concerned citizens of the African American community began a three-year battle with the Board of Public Instruction for Duval County for a better and safer building, as the then current building was a recognized fire hazard housing a large population of students. The board eventually agreed to a settlement to replace the wooden structure with the present three-story brick building. The Stanton building pictured was erected in 1917 and is located at 521 West Ashley Street. This "new and improved" facility became the main focus for the education of African American children in Duval County and the surrounding areas, from elementary to high school grades, until the 1940s, when it became a senior high school exclusively. This building is now referred to as "Old Stanton." This building was then used as a junior high school in 1953–1954 until it was converted into Stanton Vocational High School in 1954 to function as a vocational training center during the day and a center for Adult and Veterans Education at night. (Courtesy of State Archives of Florida.)

Old Stanton High School named a national historic landmark

The Old Stanton High School building at Ashley and Broad streets in downtown Jacksonville has officially become a national historic landmark.

During a gathering Sunday on the school campus to hear of renovation efforts, 200 alumni were told the school was listed on the National Register of Historic Places on Sept. 29.

The board of trustees of Old Stanton Inc., which has worked for nearly a decade to preserve the building, re-

Bettye Sessions

Journal Correspondent

The present building was erected in 1917 and used until 1971.

Among the alumni at Old Stanton

chairman; and state Sen. Arnett Girardeau, former City Councilman Earl M. Johnson, the Rev. Rudolph McKissick, Alpha H. Moore, the Rev. Frederick Richardson and Charles Simmons are members.

Tutorial program under way

The fall tutorial program, which is organized and staffed by members of the Gamma Rho Omega chapter of Alpha Kappa Alpha Sorority Inc., has begun its third year of providing assistance to students on Jacksonville's

On September 29, 1983, the "Old Stanton" building on Ashley Street was added to the National Register of Historic Places. Pictured above is a short article that appeared in the *Jacksonville Journal* in 1983. The *Jacksonville Journal* was the afternoon/evening newspaper that was a rival to the *Florida Times-Union* until 1988. This article discusses an event held on a Sunday afternoon in the fall of 1983, to celebrate the declaration of "Old Stanton" as well as to announce renovation efforts for the building to over 200 alumni that were in attendance. After housing Stanton Vocational High School from 1954 until 1971, the school had fallen into disarray. The board of trustees of Old Stanton, Inc., had worked for over a decade to preserve the building and apply for listing on the state and national registers, including efforts to generate funds in the community as discussed in the January 1979 article below. Since being renovated, this Stanton building is still serving today as an educational institution, housing a private school for grades pre-K through ninth, known as the Academy of Excellence.

Funds For Restoration Of Stanton High Urged

By JANE ALBERTSON
Journal Staff Writer

A citizen's committee is proposing the city dip into a $10.6-million pot of federal community development funds for $150,000 to begin restoring Old Stanton High School at Ashley and Broad streets.

"The committee felt Old Stanton High School had historical significance by virtue of the fact it was the first black high school in Florida and it's alumni has achieved success in many endeavors," said Robert Mitchell, chairman of the citizen's committee. "The building has signifi-

(HUD) has recommended against allocating community development funds for restoring Old Stanton High School, choosing other projects instead.

Mayor Jake Godbold and his staff began reviewing the HUD and citizens' recommendations today to formulate the administration's position on how to spend the federal dollars. City Council will make the final decision.

The consultants' $10,000 study funded last year recommends the 62-year-old building be restored and remodeled to accommodate programs

In 1868, following emancipation of slaves, the Educational Society secured $850 to buy the downtown block of land. That year, a school building was erected and named for Secretary of War Edwin M. Stanton, the consultants' study said.

A government agency set up to help newly freed slaves — called the Freedman's Bureau — conducted school in the building using white Northern teachers until 1882. The board of trustees then leased it to the Duval County Board of Public Instruction to conduct "free school therein for colored children," the consultants said

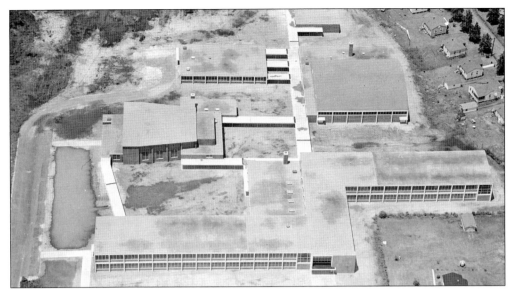

In 1953, the Stanton name was transferred to its current campus on Thirteenth Street. The picture above is an aerial shot of the entire school campus taken prior to the school opening. The school was renamed New Stanton Senior High School, as seen in the 1950s picture below. Charles D. Brooks was the first principal of this "new" school. Under his direction, from 1953 to 1968, "New Stanton" was an "honors" high school that continued to foster the same traditionally high standards befitting its rich heritage. Stanton continued to flourish as the oldest and most important high school for African Americans in the city of Jacksonville and surrounding communities, with numerous academic, athletic, and artistic accomplishments. From 1969 to 1971, the focus of Stanton Senior High School changed from academic to vocational, with the student body of Stanton Vocation High School being transferred to New Stanton High School in 1971. During this time, the revised curriculum provided for both the academic and the vocational interests of the students. (Above courtesy of State Archives of Florida.)

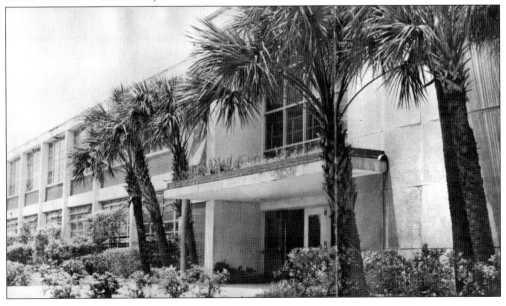

These images, photographed in the 1990s, represent Stanton College Preparatory School as it is currently. These pictures feature the recent structural changes to the front entrance of the school, with a marquee donated by the class of 1987. During the 1980–1981 school year, the focus of New Stanton Senior High School changed again to become one of the first magnet schools instituted by the Duval County School Board to serve gifted students throughout the county, changing its name to Stanton College Preparatory School (SCPS). Stanton became known as a desegregated "neighborhood" school because of its "magnet" status in the Duval school system and its open admissions policy. It opened as a magnet school for college-bound students in grades 7 through 10 in 1981 and added the 11th and 12th grades in subsequent years. During this period, the racial makeup of the school changed to reflect the city of Jacksonville's racial composition. The current mission of SCPS is to provide a highly advanced academic program for a diversity of students in grades 9 through 12.

Two

NOTABLE INFLUENCES
ADMINISTRATION, FACULTY, AND STAFF

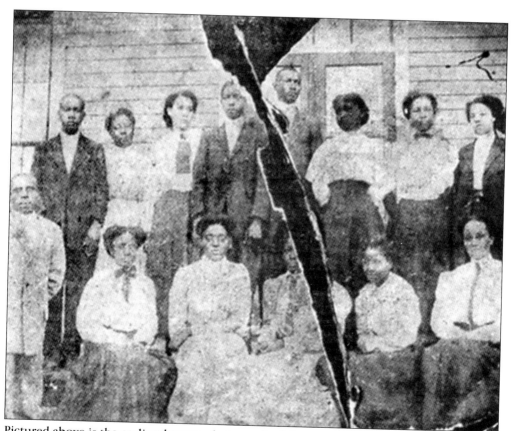

Pictured above is the earliest known photograph of the first faculty of Stanton High School standing in front of the original building sometime in the 1870s or 1880s. Stanton had its beginnings in elementary-level education. Under the administration of J. C. Waters, the first principal, and D. W. Culp, who followed as principal, the school had six grades and became known throughout the state of Florida for high educational standards.

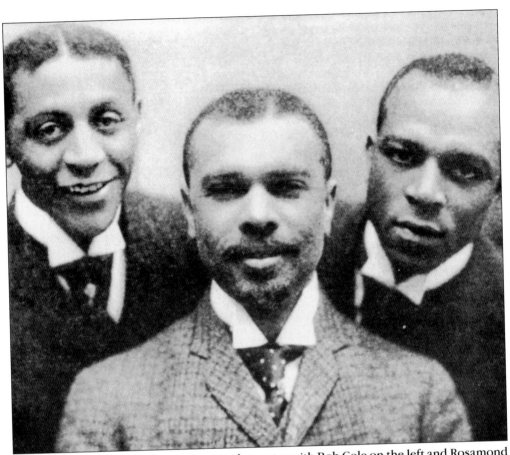

James Weldon Johnson (pictured here in the center with Bob Cole on the left and Rosamond Johnson, his brother, on the right) is a nationally acclaimed poet, musician, and educator. He is also Stanton's most well-known alumnus. Johnson was also a notable influence on the school as well as the African American community. He served as the fourth principal of Stanton, beginning in 1894, for eight years. As a six-year-old student, Johnson had the rare opportunity to shake the hand of former president Ulysses Grant while he was on a tour of Florida in 1877. Johnson attended Stanton when it was called the Stanton Normal School with his brother Rosamond Johnson (also an accomplished musician) while their mother taught there. During his administration, Johnson expanded the school from 8 to 12 grades. He also wrote "Lift Every Voice and Sing," a poem that was later set to music and became famously known as the "Negro National Anthem." He studied law and become the first African American attorney to pass the Florida Bar exam since Reconstruction. He started a newspaper, the *Daily American*, in Jacksonville before moving to New York in 1902 to become a famous composer, author, poet, diplomat, and civil rights orator. He is dubbed one of Jacksonville's "True Renaissance Men," and there is a middle school named after him in the city.

In the 1880s, the eighth grade was added under the principalship of W. M. Artrell, pictured here. Other African American principals for Stanton through the years include James Weldon Johnson, Simon P. Robinson, Isaiah A. Blocker, George M. Sampson, James N. Wilson, Floyd J. Anderson, Jessie L. Terry, Charles D. Brooks, Benjamin Durham Jr., and Jim Williams. (Courtesy of State Archives of Florida.)

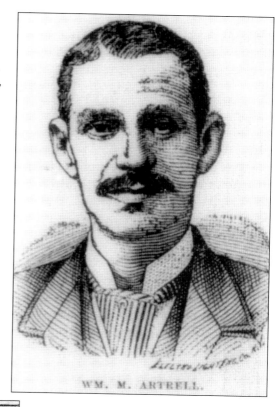

WM. M. ARTRELL.

In 1917, a musical program was held in order to raise money for the school. This program included an invocation given by Rev. John E. Ford, who in later years had an elementary school named for him in Jacksonville, and an address given by Mary McLeod Bethune, founder of Bethune-Cookman College. On the back of this program was a listing of the current faculty, pictured here.

19

This is a photograph of students and faculty in 1919, under Principal G. M. Sampson. The faculty is featured in the center of the photograph (with handwritten numbers above their heads)—from left to right, they are (back row, center) M. B. McLendon, C. Lewis, G. M. Sampson, C. DeVaughn, L. Roberts, and W. Watt.

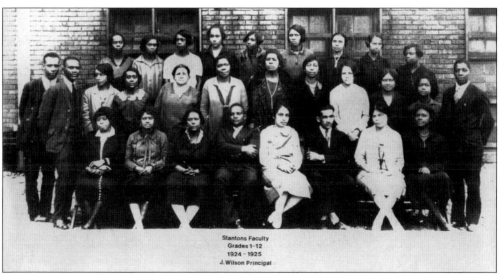

Stantons Faculty
Grades 1-12
1924 - 1925
J. Wilson Principal

Here is a photograph of Stanton's faculty during the 1924–1925 school year. The principal at this time was Prof. James N. Wilson.

FAVORITE EXPRESSIONS OF THE FACULTY.

Mrs. M. B. McLendon	"There is only one way for intelligent people to do things, and that's in an intelligent way."
Mrs. C. C. Lewis	"Well—" "Say girls!"
	"No no! child you ought know better." "Common sense ought tell you better."
Mrs. W. G. Watt	"Whose making that undertone." "P'raps."
	"Don't come straggling in my class you don't do it in any other class."
	"Have you got a book?"
Mrs. M. E. Lowe	"Have you got a book?"
Mrs. O. H. Bryant	"I would not expect that of my Senior girls."
Miss H. C. Chaplin	"Hush girls."
Miss N. A. Espy	"Yes that's right."
Prof. J. N. Wilson	"Lets have it quiet please."
Mr. R. E. Payne	"One—two—three—B-r-e-a-k."
	"Ugh, ugh."
	"Is that true?"
Mr. F. M. Moton	"I don't see why you couldn't get that." "Lets be sociable."
Miss C. K. DeVaughn	"Don't frown so Inez, Nellie." "You'll have to go out."
Mr. C. Calhoun	"Well now."—"There."
Mrs. A. B. Coleman	"Get to work boys." "Keep quiet."

LILLIAN ANDERSON, Class of '24.

The Stanton faculty for grades 1 through 12 is fondly remembered in the 1924 yearbook, with examples of favorite expressions of these teachers as heard by the students.

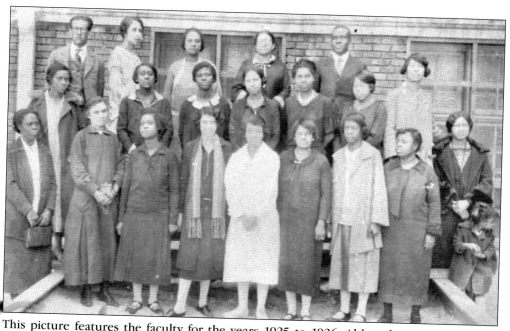

This picture features the faculty for the years 1925 to 1926. Although everyone can not be identified, this photograph includes A. Stewart, Mr. and Mrs. Beachemp, Mrs. Grant, Mrs. Harbin, Mr. Payne, Mrs. Watt, Mrs. Grant, Ms. Baldwin, Ms. Hayes, Mrs. Butler, Mrs. Johnson, Mrs. Meyers, Mrs. Payne, Mrs. Black, Mrs. A. Payne, and Mrs. Lewis.

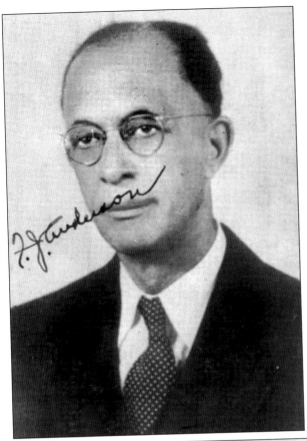

The picture at left features Floyd J. Anderson, a principal of "Old Stanton" during the 1930s and 1940s. This photograph appeared in the 1940 and 1941 yearbooks, which he personally autographed for one of his students. During his administration, Stanton's rigorous high academic standards grew as Stanton became a high school exclusively. In the photograph below is Principal Anderson, in the first row at far left, and faculty members in 1937. Many of the faculty pictured here continued to teach at Stanton far into the 1970s. Some went on to become principals and administrators at other local schools as well.

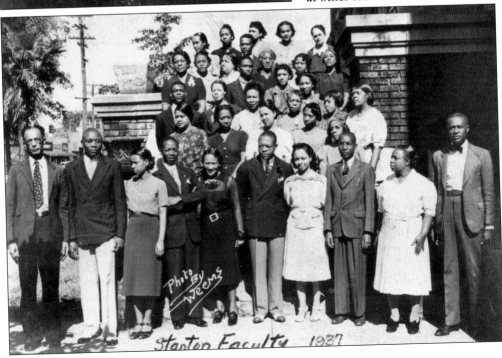

Tolbert A. Jackson was a faculty member at Stanton in the 1940s and 1950s. He taught English but was also involved with music and band direction. He left a lasting impression on the school as the writer of the alma mater, the school song. He was often the advisor for the yearbook, and he started the school newspaper, the *Stantonian*. He is pictured here in a dedication page from the class of 1961.

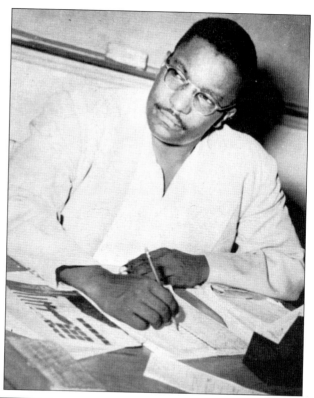

This picture features I. Emerson Bryan, a faculty member who was a key contributor to the school's yearbooks and historical records as he served as a primary photographer for the school. He was the yearbook advisor from 1947 through the 1960s. Stanton's yearbooks had the distinction of being rated among the top high school annuals. He also served as chairman of Stanton's industrial arts department in the 1960s, known to be one of the best departments in the state.

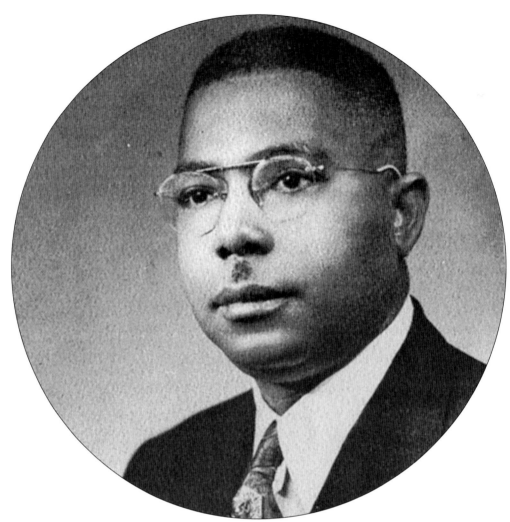

In the 1952–1953 school year, Jessie L. Terry served as the last principal of Stanton Senior High School, No. 101—now referred to as "Old Stanton" on Ashley Street. He had served since the late 1940s, following the administration of F. L. Anderson. Terry was noted for his democratic leadership style and relationships with his staff. He put emphasis on strong bodies, alert minds, and moral obligation to self, one's fellow man, and one's divine creator. He is pictured here in 1953.

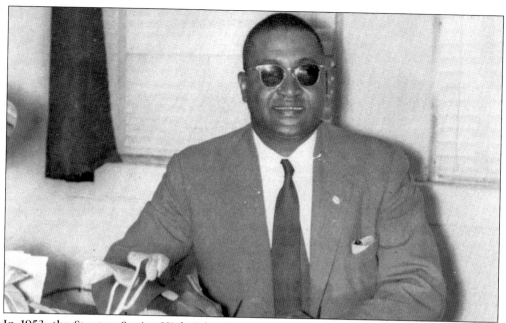

In 1953, the Stanton Senior High School name was transferred to its current location on Thirteenth Street and was renamed New Stanton Senior High School. Charles D. Brooks, pictured above in 1954, who had served as assistant principal of Stanton Senior High ("Old Stanton"), was the first principal of this new school until 1969. Known for wanting respect over popularity with the students, Brooks is remembered as a stern yet compassionate man, one who cared about his students. Brooks has stated he is most proud of the fact that many of the prominent businesspeople in the Jacksonville community completed school under his administration. Brooks believed in providing a good education to African American students during a time of segregation and inhumane treatment. One of his proudest moments as principal was in 1953, when the Florida Department of Education cited Stanton as one of the finest schools in the state. He is seen in the photograph below talking with a staff member in 1968.

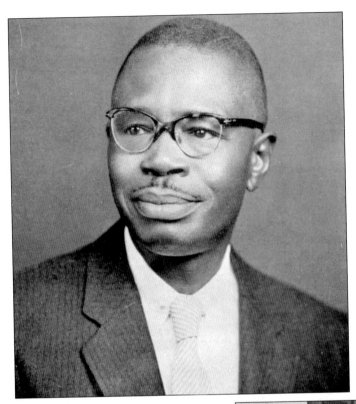

New Stanton High School had two assistant principals from 1953 to 1969, Charles F. James and Elwood J. Banks (pictured here in the 1950s). Banks was the assistant principal up through the 1960s. Banks was also known as the "Voice of the Blue Devils," as he was the play-by-play announcer for all Stanton football games and pep rallies during this era. Many students recall his "mighty voice" over the airwaves at such places as the Durkeeville Ballpark and the East-West Classic at the Gator Bowl.

In the early 21st century, Thomas Crompton Jr., a former mathematics teacher at New Stanton, produced an original book of memories about the faculty and staff of New Stanton from 1953 through 1969. Full copies of this original book may be found at the Jacksonville Public Library–Downtown Branch in the African American historical section. Pictured here is a sample page from this original book featuring Crompton's photograph. (Courtesy of Thomas Crompton Jr.)

Do you remember sitting on the bleachers
Waiting to hear in what Homeroom your name would fall?
After introductions of the 10th Grade teachers
You got the clarion call.

Mr. Charles D. Brooks, our principal,
Laid down the rules by which we all had to abide...
And Mr. Charles "Chappie" James, his assistant principal,
(And later Mr. Elwood "Homie" Banks)
Made sure that we all complied.

Then came the task of what classes we would possibly take...
English from Currie, Etheridge, Griffin,
Jackson, Littlejohn, Robinson, Scott,
Scriven, Streets, Wiles or Timberlake.

Cooking, Baking, Sewing and such...
Folson, Jenkins, Snyder,
And Mitchell taught some of us much.

In *Science* some shed frustrated tears...
With Miller, Richardson, Roundtree,
Wilson, Durham, Hart or either Fears.

We took *Archery, Dancing, Tumbling* and how to play ball...
With instructors like Pauline, Butler, Coleman,
Vinson, Montgomery, Grayson, Mitchell or "Pop" Small.

On our schedules we most certainly had to leave room...
For *Social Studies* classes taught by Butler, Lilly,
Roby, Harvey, Harris, Johnson, Davis or Broome.

All of us had to take some form of **Math**...
We all had to take classes from Jones, Solomon,
Williams, Ingram, or Crompton...
In order to head down the graduation path.

Some of us were introduced to the world of work through *D.C.T.*
Roberts and Glymp had working students to oversee.

It was a "hoot" to be in *Driver's Ed* class...
With "dare-devil" Coleman we all had to pass.

"Muy Bein Gracias", "et tu, Brutus", "parlay vous Francais"...
Did we ever get it right?
Our choices for *Foreign Language* were taught by Morris,
McFarland and White.

Our class had musical talent galore,
Developed by our *Band* instructor McFarlin,
And *Choral* instructors, Espy and Moore.

Did you go to the library like you knew you should?...
To check out a book from our Librarians Lucas or Lovingood?

Our efficient secretaries always worked hard...
New Stanton's records were kept in order by
Bowen, Kitchen and Hilliard...

Our counselors, Wyatt and Solomon,
Were to keep us on track...
They tried to make sure no one failed or "fell through the crack".

Mission accomplished, we were well on our way...
The ultimate prize was January or June 7, 1957...
Our *Graduation Day*!

By Harriett Witsell Bowens
©POETIC TREASURES

Featured here are two poems written by students from the New Stanton class of 1957, a poem by Harriett Witsell Bowens (above) and a poem by Gwen Lang Jones (below). Both were written and published in a 1957 reunion book produced for their 50th class reunion. These poems vividly recount memories of the New Stanton faculty and staff and the impressions that were made on the students throughout the years.

"THE CLASS OF FIFTY SEVEN"

C is for the Class, who joined New Stanton in 1954,
L is for the Love we felt, that will last forevermore;
A is for the Active unification of those from Stanton, Weldon and others,
S is for the Socialization that soon linked us as sisters and brothers;
S is for the Success that was yearned for, by both girls and boys,

O is for the Opportunities, that never ceased to create new joys;
F is for the Friends we cherish,
whose indelible friendships we'll have 'til we perish;

F is for Fidelity, which we've held steadfast,
I is for our Intellect, that was discovered in our past;
F is for Fantastic, which describes us very well,
T is for Tenacity, that was ingrained in our every cell;
Y is for Your talents and mine, a unique combination,

S tudious
E ffervescent
V igorous
E nthusiastic
N oble

Together they made up the "CLASS OF FIFTY SEVEN", a genuine relation.

To us, New Stanton Senior High was the best school in the land,
We proudly boasted of our choruses and admired our fabulous band;

And we knew down in our hearts, that the academics were superb,
Because whenever we competed in a marathon, we were never disturbed;

Although we knew that our faculty cared,
Oft' times our principal and vice made us scared;
Because of their gruff voices, we snapped into shape,
We all knew if we didn't, consequences we could not escape;

The blessings we realized, were abundant indeed,
For they helped satisfy our every need;

Our faculty members played their individual roles,
They were honored and implanted in our mental scrolls;

Mr. Crumpton was a gentleman and a great teacher too,
His style of teaching math made it seem simple to do;
His skill, concern and wit he combined into one,
Which made his class different and always a lot of fun;

Spanish was all that Mr. McFarland would speak,
But our shallow minds, found appreciation rather weak;
As he spoke Spanish, his experiences of Mexico were shared,
And I guess when he finished, he could tell that few of us really cared;

Mr. Bryant, our photographer, a pipe he always smoked,
And the way he compiled "The Stantonian", he was eternally stroked;

Mr. Robert's D.C.T. class was dismissed early, which left him with little to do,
So there were times when he thought he was a principal too.

Mrs. Roby, we'd agree was far ahead of her time,
For Barbio was not yet discovered, to be considered her mime;

Our drama instructor, was Mr. Matthews,
And to get on stage, you had to pay some dues;
Now some may have thought that to be cruel as such,
But one character's role of only "two words" meant very much;
She never complained, for this was not her fate,
Her main concern was to participate.

We can't forget "Our Dear Old Coach Small",
Who would yell across the gym, to make us get on the ball;

Mrs. Moore and Mrs. Espy, competitors they were,
But for many of us they were a blessing, we concur;

Since music we found was nourishment for the soul,
Mr. McFarlin, the artist, performed an incredible role;

The personification of a "real lady", was Mrs. Curry, Mrs. Wilson and Mrs. Wyatt too,
For their decorum was admired and thought the way to do;

Mr. Carter, our janitor, a faculty member he was not,
But the role he played, we never forgot;
From his role, a boycott was nearly created,
But we reached a consensus and decided to abate it.

27

MR. A. L. McFARLAND

A. L. MacFarland was an instructor for Old and New Stanton Senior High Schools and Stanton Vocational High School from the 1930s through the 1970s. He was a great scholar, instructor, and friend, teaching in the subject of various foreign languages. He earned his bachelor of science degree from Edward Waters College and took advanced studies at Hampton University and the University of Havana in Cuba. He is fondly known to many as "Mr. Mac" and was honored in the 1961 yearbook as pictured here.

Mary Barnett Mitchell, pictured here in 1965, was recognized in 2008 for being the oldest living member of Old and New Stanton High School, having taught there from the 1930s through the 1970s. As a teacher of home economics, she was magnificent in her efforts to encourage her students to sew all types of clothes, from raincoats with matching umbrellas to gowns for the prom. Many of her students have gone on to greatness in the world of fashion with knowledge of fashion and how to use it to the best of their ability.

Ruth Cummings Solomon, pictured here in 1965, was known as an outstanding mathematics teacher at both Old and New Stanton High School for over 27 years. A beloved teacher through the 1950s, 1960s, and 1970s, she was better known by the nickname "Cutie." Solomon greeted all with a caring smile. She always encouraged students to think "mathematically with common sense." She was well loved by students for the time she always took to help them learn.

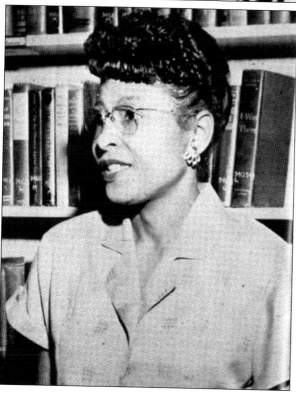

Nancy Scriven Watts was known as an excellent teacher at New Stanton, as she instilled in her students a respect for Shakespeare and Greek mythology. Scriven Watts has a love of writing and literature. She always anticipated her student's vulnerabilities and encouraged them to strive for more. Pictured here in 1960, she is remembered fondly as a teacher who pushed the students to "write, think, and reflect on their own written words." She was a member of the class of 1937 and taught at New Stanton from the first class in 1953.

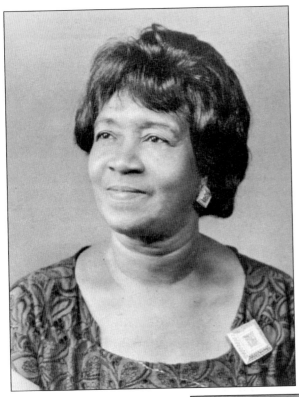

Mamie Louise Butler taught social studies at Old and New Stanton High School. She was a caring but strict teacher who exhibited her love of history and artifacts throughout her years of teaching. Her service to Stanton students over 30 years is well documented by many of the graduating classes that gave her mementos as heartfelt "thank yous" for the encouragement that she provided to them. She is pictured here in 1968.

Alice L. Griffin was an English teacher at Old and New Stanton from the 1940s through the 1960s. She was a cherished teacher who was known for an untiring attitude towards the development of minds. She was known affectionately as "Ma Griff" or "The Griff" as she worked tirelessly to build up the confidence and character of her students. With an endless number of sayings and expressions like "My Boy! Isn't He Grand!" to encourage some of her male students who might be underperforming in some way, she was also dubbed as "the lady with a thousand faces." Her former students fondly remember learning a lot about self-respect, respect for others, and of course, the subject of English.

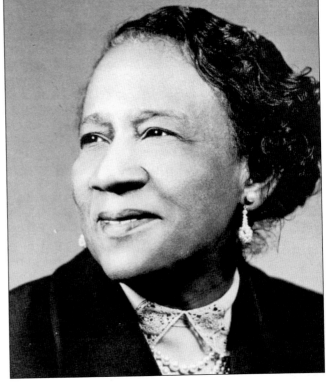

Through the years, Old Stanton, New Stanton, and Stanton Vocational High Schools have had a staff of noteworthy teachers who have taught at the highest standards in core academics and vocational training. Stanton has been recognized as one of the finest African American public high schools in Florida, an honor that would not have been possible without the hard work and dedication of its administration, faculty, and staff. Pictured here are listings of all known faculty from these schools as they appeared in a 2007 Annual Gala Program honoring the three schools of Stantonians. Of note, the former students, faculty, and staff participate in reunion events as well to remember and reflect on their times at Stanton. (Both courtesy of 2007 Annual Stanton Gala Committee.)

STANTON•NEW STANTON•STANTON VOCATIONAL FORMER FACULTY & STAFF

Akery, William R.	Dickerson, R. (Mr.)	Jackson, Tolbart A.
Anderson, F.J.	Doe, Ruth P. Whitelock	James, Charles F
Anderson, Gary L.	Dorsey, Willie	Jenkins, Adelaide L.
Argrett, Thelma	Duncan, Daisy	Johnson, Billie K.
Artrell, W. M.	Durden, L. H. (Mrs.)	Johnson, Elvira
Austin, W. L. (Mrs.)	Durham, Ben Jr	Johnson, James Weldon
Bailey, Herschel A.	Dwight, Rubye	Johnson, Jimmie
Banks, Elwood J.	Ellis, Vivian	Johnson, Virginia
Bartley, Sylvia A.	Espy, Annette M	Jones, Betty
Bennett, D. M. (Mrs.)	Etheridge, Louise F	Jones, Coatsie
Blakely, Vera	Everette, T C (Mrs.)	Jones, D. M. (Mrs.)
Blanchard, Katherine	Fears, Clarence C.	Jones, Thelma Hair
Bland, N. D. (Mr.)	Fisher, Audrey C.	Joyner, R. E. (Mr.)
Blocker, I. A.	Flanders, Joe R.	Kelly, Isabelle A.
Blossom, Nancy P	Folsom, Sarah F	Kennedy, Theresa C.
Borden, C. (Mr.)	Franklin, L. C. (Mr.)	King, Mable P
Bostick, Clarence Von	Gadling, Minnie	King, Myrtis C.
Bowens, Georgiana C. (Mrs.)	Gay, Eleanor J.	King, Myrtle B.
Brooks, Charles D.	Gibson, L. B. (Mrs.)	King, Ondria
Broome, Ruth M.	Glover, R. N. (Mrs.)	King, Romus
Bryan, I. Emerson	Glymp, Lucylle J.	Kitchings, Elaine F
Bryant, Annie M.	Graham, Betty H.	Knox, Iris L.
Bryant, Olivia Smith	Graham, Edgar	Lawson, Edwin H.
Brymer, R. L. (Mr.)	Grayson, Isaac M.	Lewis, Carrie C.
Buggs, Clifford	Green, William W	Littlejohn, Frances X.
Bullard, W. (Mr.)	Greene, B. C. (Mrs.)	Littlejohn, Norma J.
Butler, Mamie L.	Greene, James	Loney, Audry G.
Butler, Sibyl P	Griffin, Alice L.	Lovingood, Estelle B.
Butler, Teresia Kennedy	Hamilton, Frank W	Lucas, Willie L.
Canty, Ben L.	Hammond, C. L. (Mrs.)	Mackey, Pearl K.
Carley, C. N. (Mrs.)	Hampton, Mildred J.	Mangram, Gwendolyn C.
Carter, Maggie	Hargrove, Dan P	Marshall, Eddie B.
Cave, Minnie C.	Harper M. L. (Mrs.)	Martin, Emma
Christopher, M. M. (Mrs.)	Harris, Clementine M.	Mathews, Edwin N.
Cobb, E. (Mrs.)	Harrison, Myrtia	Mathis, Clarence F
Coleman, John J.	Hart, A. M. (Mrs.)	Maxwell, Charles T
Coleman, Lucille G.	Hart, John S.	Maxwell, Gwendolyn D.
Coleman, Mary Farmer	Hart, V Lois	McBride, R. (Mr.)
Cooper, Clara H. Durham	Heard, A. (Mr.)	McFarland, Alvin L.
Cottrell, A. W. (Mr.)	Higdon, Elizabeth G.	McFarlin, Kernaa D.
Cowart, V P (Mrs.)	Hill, A. (Mrs.)	McGee, F. P (Mrs.)
Crawford, Jerusha	Hilliard, Geneva A.	McIntosh, Annie M.
Crompton, Thomas Jr	Hines, W (Mr.)	McLendon, Martha B.
Crump, Nellie	Holley, Gail Waldon	Meeks, Carole A.
Cruse, V W (Mrs.)	Howard, Hillie	Miller, Raymond S.
Culp, D. W	Huges, C. (Mr.)	Mitchell, J. M.
Currie, Amy S.	Ingram, Vivian O.	Mitchell, Mary B.
Daniels, Alma C. Monroe	Isaac, Clevel D.	Monroe, Grace S. Vinson
Daniels, O. (Mr.)	Jackson, Juanita Kite	Montgomery, Theodore W
Davis, Daniel W	Jackson, L. B.	Moore, Alpha Hayes
Davis, Vera	Jackson, Reid E. II	Moore, Richard
Dennis, H. W. (Mr.)		

STANTON•NEW STANTON•STANTON VOCATIONAL FORMER FACULTY & STAFF

Mosley, P. D. (Mr.)	Streets, Marie B.
Muldrow, William P	Stubbs, Vincent R.
Nairn, George	Sumpter, G. W (Mrs.)
Nelson, C. Pearl	Sweet, William D.
Newton, Ollie M.	Terry, J. L.
Oliver, C. J. (Mrs.)	Thomas, Elbert
Onfroy, Brenda P	Thomas, Myrtis C.
Owens, D. S. (Mrs.)	Thurston, Minnie L. Gadling
Payge, Francis O.	Timberlake, Ruth B.
Payne, Emilee Jones	Turner, B. B. (Mrs.)
Pearson, B. J. (Ms.)	Turner, E. L.
Pelham, C. (Mr.)	Twiggs, Aaron R.
Pollard, A. C. (Mrs.)	Vaughn, Meltonia Lilly
Preston, A.	Waldon, Francis
Prime, Annette	Walker, W. R. (Mr.)
Rasberry, Wallace S.	Washington, Martha J.
Reed, C. T	Waters, J. C.
Reed, Yvonne A.	Watts, Nancy Scriven
Rice, William M.	Weaver, H. E. (Mrs.)
Richardson, Ethel	Weston, Laconnetta
Richardson, F. D. (Mr.)	Whipple, G. L. (Mrs.)
Roberts, Rodell F	White, Eugene L.
Robinson, Annie	White, Mildred
Robinson, Christine	White, Ruth Smith
Robinson, E. M.	White, Walter H.
Robinson, Helen	Whitelock, R. P
Robinson, Kermit E.	Whitfield, Clayton O.
Robinson, Lillian T	Whitfield, Frankie
Robinson, Robert R.	Wiles, Vera C.
Rogers, Erma Wiggins	Williams, Annice G.
Rooks, Fannie	Williams, Delores Z. Pearson
Roundtree, Charles J.	Williams, Ike
Russell, Nellyvonne T	Williams, L. A. (Mr.)
Sampson, G. M.	Williams, Lecretea Harvey
Sanders, Irma J.	Williams, Sammie
Sanford, W. N. (Mr.)	Williams, Teresa S.
Schell, Harriet	Williams, Willie P
Scott, Helen R.	Wilson, Almira H.
Scriven, Nancy S.	Wilson, Ernest L.
Shelton, G. (Ms.)	Wilson, J. N.
Sheppard, J.	Wilson, Louise Hampton
Silas, Randolph E.	Wilson, Sadie
Simmons, Susie D.	Wooden, Otha L
Sims, Queenester Crumbley	Wyatt, Juanita, D. Graham
Singleton, Mr	Young, Mary E. B.
Small, James P	
Smith, Priscilla	
Sneed, A. B. (Mrs.)	
Snyder Georgia B.	
Solomon, J. H. (Mr.)	
Solomon, Louvenia E.	
Solomon, Ruth C.	
Speights, O. (Mr.)	
Stanfield, Emanuel A.	
Steeley, James	

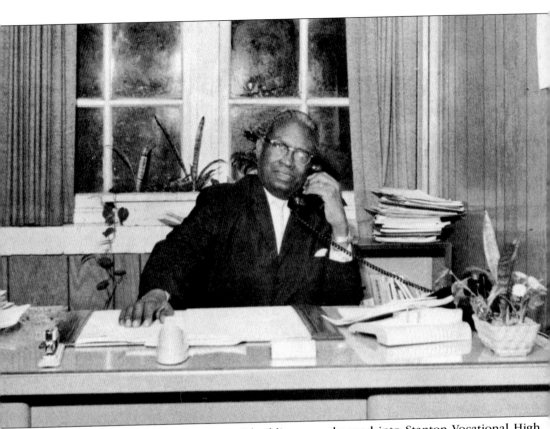

On Ashley Street, the "Old Stanton" building was changed into Stanton Vocational High School from 1954 through 1971. It functioned as a vocational training center with a curriculum focused on training students in technical skills. At night, it became a center for the Adult and Veterans Education Program, and eventually a branch program of Florida Junior College. During these years, there was a day and an evening principal at Stanton Vocational High School. Pictured here is William D. Sweet, an evening principal of Stanton Vocational in 1970. Sweet left a lasting impression on several Stanton students through the years. Sweet served on the faculty at both Old and New Stanton since the 1930s and eventually served as the evening principal for Stanton Vocational High School during the 1960s and 1970s. In terms of day principals for Stanton Vocational High School, Leroy Jackson served during the 1950s and 1960s and Edward Lawson served from 1969 through 1971.

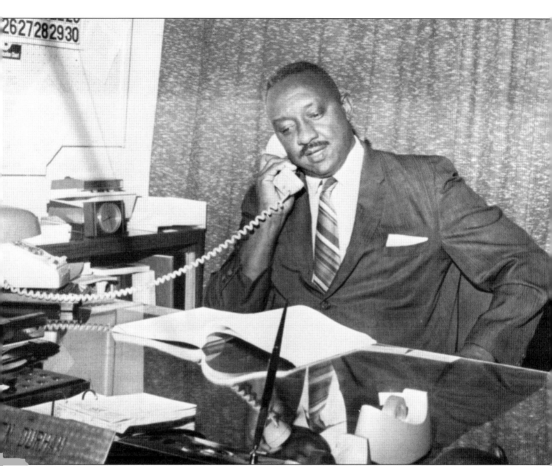

Pictured here is Ben Durham, the principal of Stanton Senior High School from 1969 until its change to Stanton College Preparatory School in 1980–1981. Durham was a former principal (1966–1969) and vice principal of Stanton Vocational High School. While Durham served as principal at New Stanton, in 1971, the student body of Stanton Vocational High was transferred to New Stanton Senior High School and the building on Ashley Street was closed. The curriculum of Stanton Senior High School, as it was again referred to during this time, was revised to provide for both the academic and the vocational interests of the students throughout the 1970s. During this time, the faculty and staff became more integrated, yet the student body remained solely African American until the 1980s.

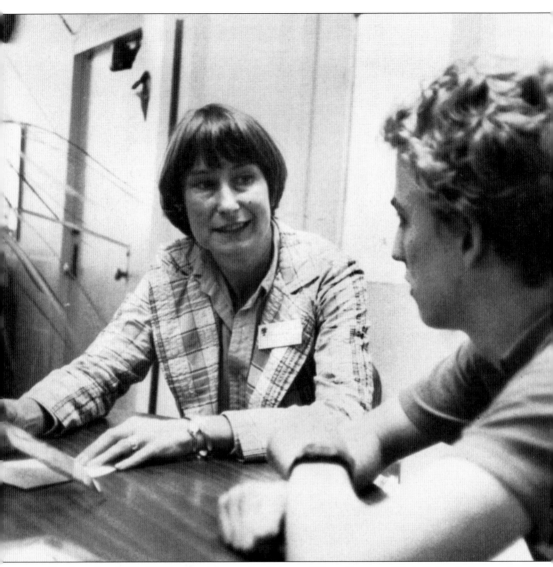

During the 1980–1981 school year, the focus of New Stanton High School changed to its current format—a magnet school for gifted students throughout the county. The school was renamed Stanton College Preparatory School, and Carole Walker was the first principal appointed there. Seen here with a student in 1984, Walker was known for making it a priority to know every student and faculty member. She was quoted as saying, "They are the best in the world!" Originally from Texas, she pursued her graduate studies primarily in Florida before serving at Stanton for four years. From 1981 to the present, Stanton College Preparatory School has had eight principals: Carole Walker (1981–1985), Veronica Valentine (1985–1988), Lynda Lewis (1988–1991), Jerry Gugel (1991–1992), Jim Williams (1992–1995), Ed Pratt-Dannals (1995–1997), Jim Jaxon (1997–2004), and Debra Lynch (2004–present.)

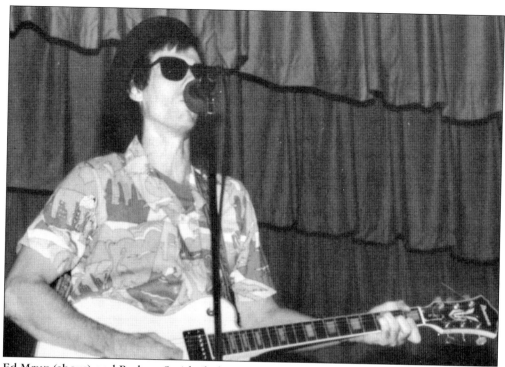

Ed Mruz (above) and Rodney Smith (below) are current faculty members who have been at Stanton College Preparatory School since its beginning in 1980. Mruz is a French teacher who is adored by students. In this picture, taken in 1990, he is seen in a less formal role as he is playing in the Hubcaps, a band of Stanton faculty that formed in 1983 and played "golden oldies" at various Stanton activities in the 1980s and 1990s. Below, Rodney Smith, a mathematics teacher, is seen in 1986, working hard on class preparation, as he is known to keep his students "too busy to fall asleep in class." He is also the current coach of the varsity cross-country team.

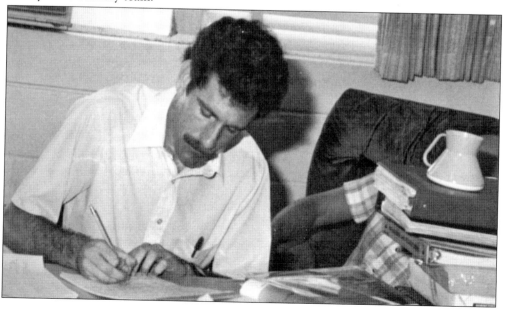

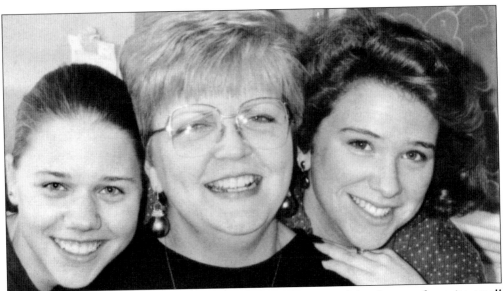

Meg Mixon Hawley has seen Stanton College Preparatory School grow from its small beginnings in 1980 to its rather larger size currently. She believes, however, in the value of individualized attention and interpersonal connections with students despite the size of the student body. She is currently an English teacher at Stanton who has been recognized as a student "favorite" several times through the years. She has also served as an advisor for various clubs through the years. Seen here in 1993, Hawley is known as an inspiration to students through her challenging yet caring teaching style.

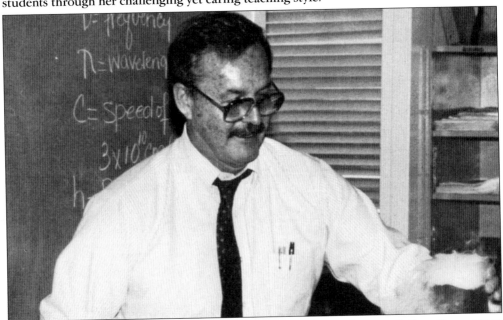

Otto Phanstiel (now deceased) was a former science teacher at Stanton College Preparatory School. While serving at Stanton, he was a student favorite as he presented wild experiments and "weird" science in his classroom daily. In 1995, he was recognized by Disney as one of the top three science teachers in the country during the Disney Teacher of the Year awards. Students have remarked that he could teach chemistry to anyone.

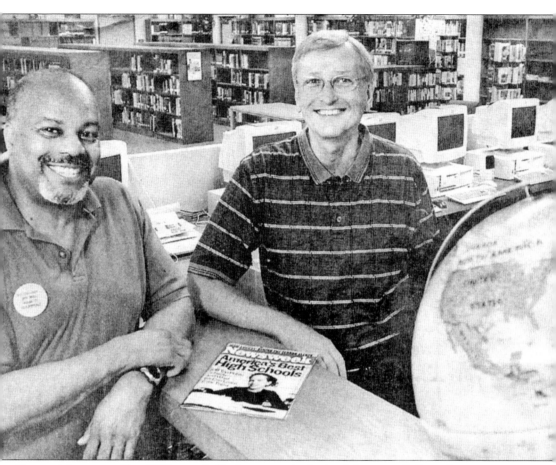

Pictured here are Jim Williams (left), former principal of Stanton College Preparatory School and then principal of Paxon School for Advanced Studies, and Jim Jaxon (right) when he was principal of Stanton. This photograph appeared in a *Times-Union* news article that discussed how both schools were designated by *Newsweek* magazine as two of the best high schools in the country. Dr. Jim Williams has been the only African American principal of Stanton College Preparatory School, serving from 1992 to 1995. From 1997 to 2004, Jim Jaxon, as principal of Stanton College Preparatory School, served the students, faculty, parents, and community. He was also known for celebrating the accomplishments of students, and he would do things like hand out ice cream during lunch to students who received straight A's. He has also left an indelible mark on the Stanton legacy by providing his full support for the establishment of the Stanton Cultural Heritage Committee in 2001.

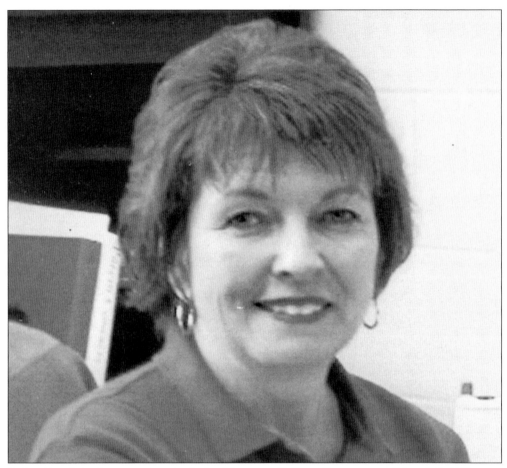

Debra Lynch is the current principal of Stanton College Preparatory School. Building on the foundation of support for the Cultural Heritage Committee, established under Jim Jaxon, Lynch has been a staunch advocate for linking the historical legacy of Stanton with the current growing body of students and alumni. It is with her support that this book is possible. Lynch is recognized by her students and staff for her level of genuine concern and dedication to the school community. She is recognized by current students as one who takes time out to reach out to them and to know them on more than an academic level. Lynch is strong in both leadership and guidance with faculty and students. In the morning, she can be seen greeting students. By noon, she meets with administrators. More importantly, she makes a point to attend every home football game with great "Stanton Pride"!

Three

STUDENT LIFE
ACADEMIC AND CO-ACADEMIC PURSUITS AND TRADITIONS

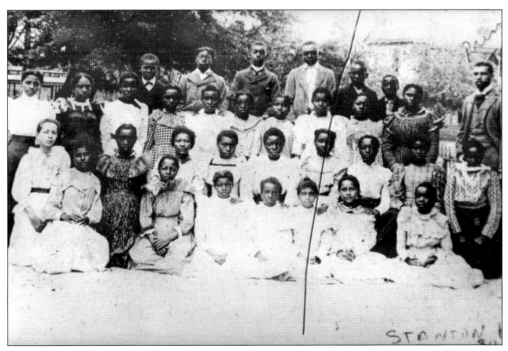

This photograph of Stanton students was taken sometime between 1894 and 1902, when James Weldon Johnson was on faculty and principal. Johnson is featured in the back row on the right.

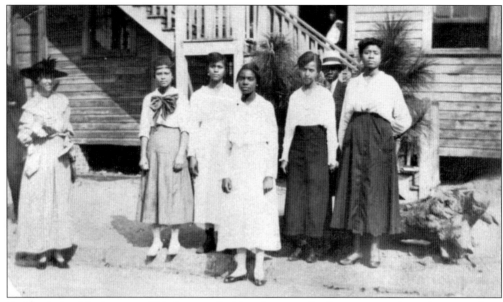

Dubbed the "Quintet at Old Stanton," this photograph shows several students in their freshman year in front of the wooden building of Stanton in 1916. The second young woman from the right is Amy Stewart, who later became Amy Stewart Currie. Currie was on faculty for over 40 years, teaching at both Old and New Stanton High Schools. Also in the photograph are, from left to right, Eloise Sampson, Kathleen Crocket, Rossie French, and Alberta Brooks.

Class History

At last, we have reached our long desired goal graduation!

Four years ago one hundred twenty-eight eager, care free girls and boys entered Stanton High School of which a little less than one fifth of that number are members of the graduating class. At first the high school routine was very strange but very soon we became used to and liked it.

In September nineteen hundred twenty-one we began our sophomore year. It was at the beginning of the year that our principal, Mr. James N. Wilson, greeted us. Under the supervision of Mrs. W. G. Watt our history instructor we gave very successfully the Slab Town Convention. From this entertainment we received very near one hundred twenty-five dollars and very heartily gave fifty dollars to the Library fund and fifty dollars for flowers to help decorate our beautiful campus.

Our Junior year, which we recall with the most pleasant of memories, was filled with many very pleasing incidents. About the middle of the year we elected our class officers for our senior year. Mr. Rolando Slaughter was elected president, Miss Hermia Anderson, vice-president, Miss R. L. Young. secretary. Then came our Junior Vodvil, a delightful affair, which was filled with youth and jollity. Following our Vodvil very closely was our Junior Promenade to the Seniors, the never to be forgotten entertainment of our lives.

It was during the east part of this year that we lost so many of our original member. At least twenty became quitters just after the mid-term examination.

Thus we began our senior year. Henry Mitchell, Eunice Emanuel, Elvis Stubbs and Willia B. Cummingham joined our number. Mr. LeRoy M. Washington was chosen to guide the largest class in Stanton's history, as our former president did not return. Mr. F. N Norton was greeted as our science instructor. Mr. Asbury Johnson, an active member of the class of '24 was elected as a delegate to represent Stanton High School at the Y. M. C. A. Convention at Kings Mountain, North Carolina and six of our boys William Harrison, Verdell Covington, LeRoy Washington, Asbury Johnson, Henry Mitchell, and Robert Hooks received sweaters and letters as members of Stanton's Varsity team.

The four years that the class of '24 has spent in Stanton have been glorious days. Days that time can't easily erase from our memories. The class has always been loyal to Stanton not because we knew it was our duty but because of the great love we have for our school. In our small, but sincere way we have always tried to shoulder and put over everything that our school has been a factor in. We are leaving greatly impressed by the instructions of the teacher, whom we will never be able to forget and sincerely hoping that our successors will continue to push Stanton on, on, to victory.

Long, long will our hearts with dear memories be filled as a vase in which vases have once been distilled. You may break, you may shatter the vase if you will. But the scent of the roses will hang round still—Moore.

INEZ BROWN, Historian, Class '24.

In this image, taken from the 1924 yearbook, a graduating senior reflects on the students' experience at Stanton during that time. In this short essay, Inez Brown, the class historian, recounts the experiences with faculty and classmates from 1920 to 1924.

THE STANTONIAN

Official Organ

of

STANTON HIGH SCHOOL

Published by the Class of 1924

Under direction of The English Department

Established 1924

THE STAFF

Editor, Leroy Washington, '24.	Ass't. Cir. Mgr. Louis Randolph, '26.
Asso. Edt., Hermia Anderson, '24.	Exchange Edt., Anna Williams, '24.
Asso. Edt., Lillie Dawkins, '25.	Athletic Editor, William Harrison, '24.
Eus. Mgr., Verdell Covington, '24.	Alumni Editor, Mattie DeBose, '24.
Ass't. Mgr., Henry Wynns, '25.	Social Editor, Inez Brown, '24.
Circulation Mgr., Asbury Johnson, '24.	

FACULTY DIRECTORS.

Prof. James M. Wilson Mrs. M. B. McLendon.

Dedicated by the Class of '24 to the Faculty

CLASS ROLL

Hermia Lee Anderson,	Algurnia Erzuhart Myers,
Lillian Simmons Anderson,	Sylvia Amanda Mungen ,
Inez Juanita Brown,	Henry Eugene Mitchell,
Nellie Ward Brooks,	Ernestine Winfred Moore,
Verdell Turner Covington,	Julia Margaret Potter,
Willie Belle Cunningham,	Ella Dorothy Purcell,
Mattie Olive DeBose,	Clarice Elmer Pinkney,
Eunice Merritt Emanuel,	Mercedes Laura Mae Richardso
Alonza Vernon Guyton,	Ruby Ernestine Rivers,
Rebecca Bernice Haywood,	Evvis Garvin Stubbs, ,
Willa Belle Hayes,	Roselle Arneita Sapson,
Robert V. Hooks,	Anna Alicia Williams,
Pearl Beatrand Holman,	Julia Belle Williams,
William Henry Harrison,	LeRoy Marlowe Washington,
Asbury Ruskin Johnson,	
Omega Alpha Lavett,	Rosa Lee Young. ,

These images give us more information about both faculty and student activities in the 1920s at Stanton. At right is a listing of the senior class for that year (bottom of the image). Below is the program of events for the class of 1924 commencement activities (which apparently lasted through the duration of a week). At the time, the graduating class consisted of about 30 seniors.

CALENDAR OF EXERCISES

SUNDAY, JUNE 8th, 4:00 P. M.
Annual Sermon to Graduating Class.
The Rev. W. C. Brown, Pastor,
Tabernacle Baptist Church, Jacksonville, Florida.
MONDAY, JUNE 9th, 8:00 P. M.
Senior play—"The Dust of the Earth."
Auditorium of School.
WEDNESDAY, JUNE 11th, 3:00 P. M.
Annual Exhibit of Industrial Departments,
Joint Closing of Eight Grades of Six Grammar Schools at 4:00 P. M.
Class Day Exercises, 8:00 P .M.
THURSDAY, JUNE 12th, 10:00 A. M.
Commencement of High School,
Alumni Reception to Class 8:00 P. M.
NOTE:—All exercises at the School.

CLASS DAY PROGRAM

I.

Ivy planting exercise on the Campus.
Song ... Class
Ivy Oration and Spade presentation to Juniors Mr. Robert V. Hooks.
Response ... Mr. Henry B. Wynns, '25

II.

Invocation ... Miss Ruby Rivers.
Piano Solo ... Miss Pearl Holman
Presidents farewell address Mr. LeRoy M. Washington.
Giftorian .. Miss Ella D. Purcell.
Vocal Solo ... Mr. Robert V. Hooks.
Class Poem Miss Algurnia Eriquhart Myers.
Class Oration Mr. William Henry Harrison, Jr.
Song ... Congregation
Class History Miss Inez Juanita Brown.
Class Will Miss Rebecca B. Haywood.
Class Prophecy Miss Wila Belle Hayes.
Class Song .. by the Class.

COMMENCEMENT
Thursday, June 12, 1424.

Processional.
Chorus .. "I'll Never Turn Back No More."
Choral Class—R. Nathaniel Dett.
Invocation.
Response.
Solo ... "Goodbye Sweet Day."
Robert Hooks—Kate Vannah.
Hungarian Rhapsody Josef. Low.
Two Pianos.
Female Chorus .. Carmena.
Choral Class—H. Lane Wilson.
Introduction of Commencement Speaker.
Commencement Address Mrs. J. C. Wright.
Violin Solo ... Edward Lewis.
Selected.
Presentation of Diplomas.
Grand Valse Caprice Hans Engleman
Eight Hands.
Chorus ... Waves of the Danube.
Choral Class—I. Ivanovici.
Benediction.
NOTE—Presents to graduates must not be presented at the school.

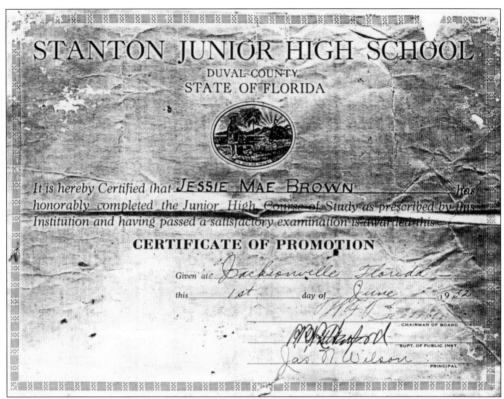

Pictured here is a 1932 certificate of completion for a student in 1932. At this time, Stanton was still a junior and a senior high school and James Wilson served as the principal.

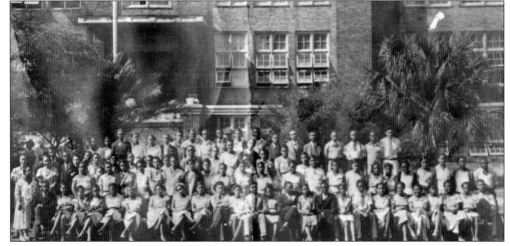

The 1933 class was the largest class to graduate from the school at that time, 110 students. Although most students in the class were the first in their family to complete high school, this class launched generations of doctors, teachers, ministers, and civil servants after graduating from Stanton's programs of academic excellence. The remaining members of this class still meet regularly for reunions to this day. (Courtesy of State Archives of Florida.)

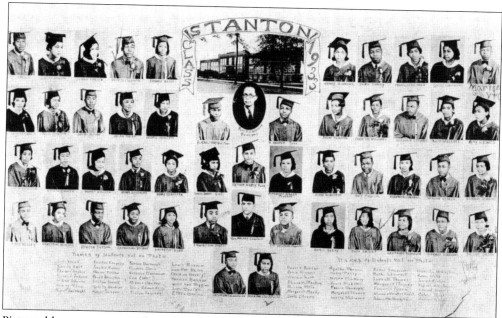

Pictured here are two professional photographs of the 1933 graduating class by Ellie Weems, also known as "The Photographer of Black Jacksonville." These photographs, treasured by Jerusha Shaw (Guyton) and Marion Guyton of the 1933 class, proudly display seniors, officers, and Principal Floyd Anderson. This class also included A. C. Madry, the class president, who went on to become a principal of a school in Duval County and a recognized community citizen; Warren Shell, who later became a physician and leader in the Jacksonville community; and Winona Vanderhorst (Britt), a former teacher at Stanton who was better known as "Nona" and whose father was one of the first Stanton trustees. (Both courtesy of Chiquita and Jerusha Guyton.)

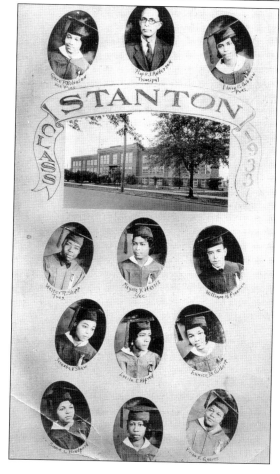

43

Stanton Senior High School

Jacksonville Florida

This Certifies That

Dorothy Wise

has honorably completed the College Preparatory Course of Study prescribed for the High School Department and is entitled to receive this

Diploma

by order of the Duval County Board of Public Instruction

June 8, 1938
Date of Award

F. J. Anderson
Principal

Margaret P. Weed
Chairman

R. K. Kendall
Superintendent

Dorothy Wise was a 1938 graduate of Stanton Senior High School, as shown in this diploma from that time (above). F. Anderson was her principal. She is also shown in this page from her class yearbook (in the upper left corner). Also featured in this picture are several of her classmates: Jessie Mae Belle, Elnora Marie Law, Susie Mae Jones, Evelyn Eartha Hubbard (Galvin), Warnie Lee, Ola David, Elvin Young, Bennie Mae Watkins, Edith Ory Jones, Edmonia Lynez Allen, and Sylvester Gwendolyn Leggett. (Both courtesy of Francis Yvonne Hicks.)

44

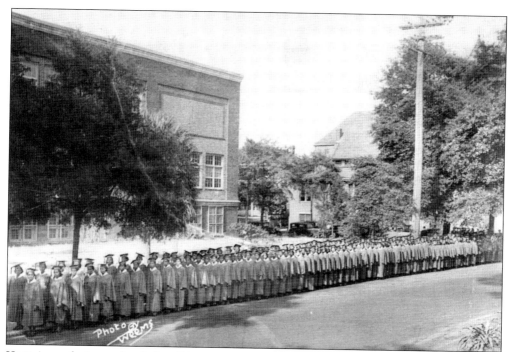

Here is a photograph of the 1938 graduating class, taken in front of the Ashley Street building by photographer Ellie Weems. Again, the impressive march of students is seen as neighbors watched from the curb and the seniors promenaded down the short block from the school at Broad and Ashley Streets to the Strand Theater on Jefferson Street for their commencement ceremony.

Honor Graduates of Stanton High School

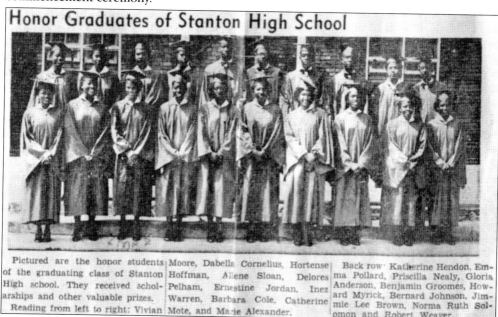

Pictured are the honor students of the graduating class of Stanton High school. They received scholarships and other valuable prizes. Reading from left to right: Vivian Moore, Dabella Cornelius, Hortense Hoffman, Allene Sloan, Delores Pelham, Ernestine Jordan, Inez Warren, Barbara Cole, Catherine Mote, and Marie Alexander. Back row: Katherine Hendon, Emma Pollard, Priscilla Nealy, Gloria Anderson, Benjamin Groomes, Howard Myrick, Bernard Johnson, Jimmie Lee Brown, Norma Ruth Solomon and Robert Weaver.

Here are the honor student graduates from 1951, featured in a local newspaper article. They were featured for the scholarships and other prizes received in recognition of their academic accomplishments. (Courtesy of Hortense Hoffman Ford.)

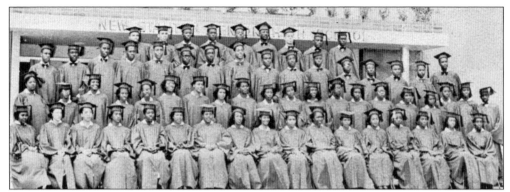

In 1953, the Stanton name was transferred to its new (and current) building on Thirteenth Street. Featured in this photograph, taken in the midterm of 1954, is the first graduating class of New Stanton High School.

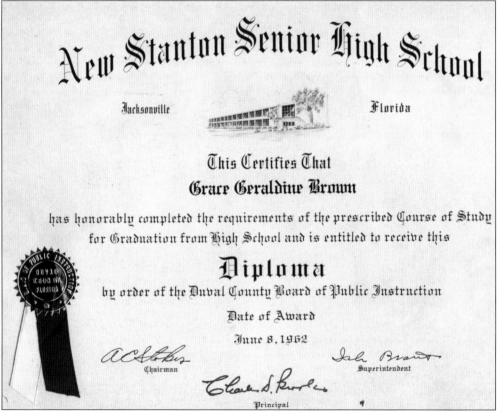

This is an example of the diploma received by New Stanton graduates. This diploma was received by this book's author, Grace Brown (Galvin), in 1962 under the principalship of Charles Brooks.

Every graduating class has senior class officers that take a leadership role in sponsoring various activities for seniors as well as the larger school community—from weekly social events to fund-raising events. Pictured here are some of the class officers from Stanton College Preparatory School. The 1986 class officers are in the above photograph, and the 1990 class officers are shown, in a nontraditional pose, in the photograph below. The 1990 class was particularly active, as the picture suggests. One of their notable projects from that year was repainting the senior lounge.

Although Stanton College Preparatory School started in 1981, the first senior class of 54 students matriculated in 1984. In this photograph are three seniors, several years later, contemplating something during their 1989 commencement activities. That year, they were introduced by Allen Rush, a social studies faculty member, and Principal Lynda Lewis gave the welcoming address.

Pictured here are excited graduating seniors from the class of 2002. They are displaying pride and excitement during the annual pep rally.

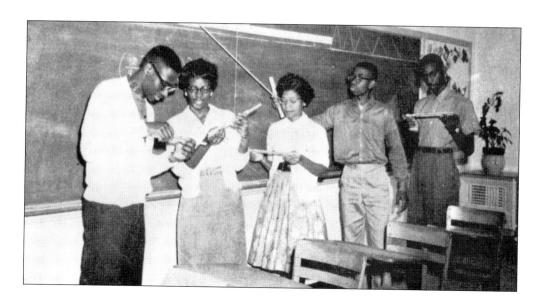

Shown here are several students in various academic classes at New Stanton High School in the 1960s. Above are some students in a trigonometry class in 1962, and below are some students from 1964 "experimenting" in a science course.

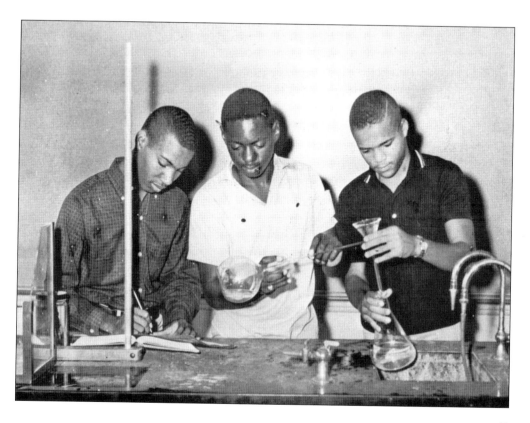

In the 1960s, the Duval Public Schools began a program where various high schools would produce or present course information that was to be televised throughout other schools in the county. Here are the students and teacher from the social studies class for the 1963–1964 school year who participated in this television programming.

Here is a 1965 photograph of a driver's education course at Stanton Vocational High School, which was always a popular class. In the 1960s, cars were often donated by a local car dealership, who would post the dealership's name on the cars as advertising to up-and-coming young drivers.

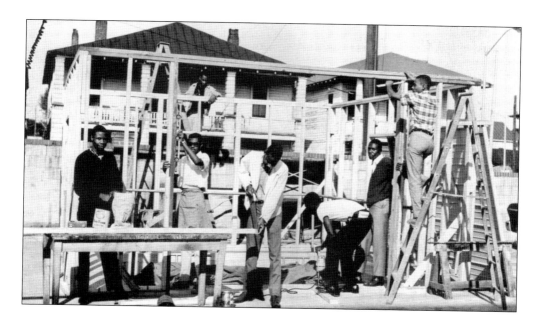

These are two examples of the type of vocational training given at Stanton Vocational High School in the 1960s and 1970s. In the above photograph, students from the 1965–1966 school year are in a "cabinet making shop" class, where they are constructing a building to be used by the auto mechanics shop class. E. L. Wilson is the instructor pictured here with several juniors and seniors. Pictured below is a radio and television repair class. In the photograph are several seniors and C. J. Jackson, the instructor. Students learned to measure direct current and how to build circuits for the measurement of currents. Vocational training also extended to other topics such as practical nursing, tailoring, shoe repair, clothing construction, and upholstery.

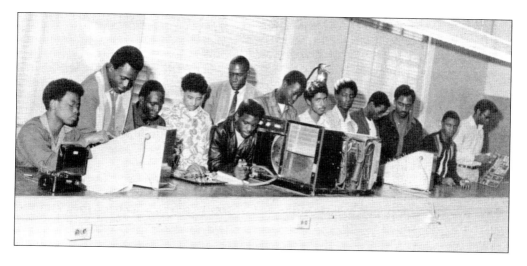

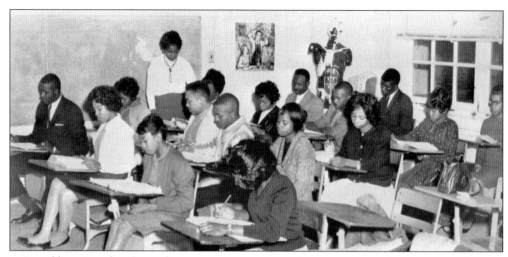

Pictured here is a chemistry class at Stanton Vocational High School in 1965. Although it was primarily a vocational school, there were several courses in foundational academic areas as well as those aimed toward college preparation, as the evening program had a wider age range of students. The school often housed several courses for local junior colleges as well.

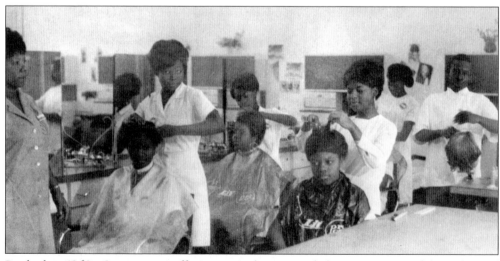

By the late 1960s, Stanton was offering several vocational classes as a part of the industrial arts department. Topics ranged from general metals, electronics, cabinet-making, auto mechanics, and graphic arts to cosmetology, as pictured above. Stanton offered these classes for students who were more interested in developing a trade or skill for various reasons. Interestingly, industrial arts classes were a requirement for all male students, whether they were college bound or not.

In this history class from the 1991–1992 school year, students often described lectures as "history re-lived."

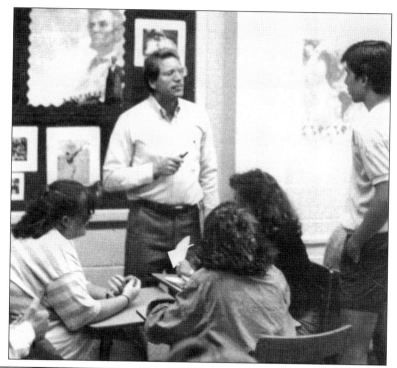

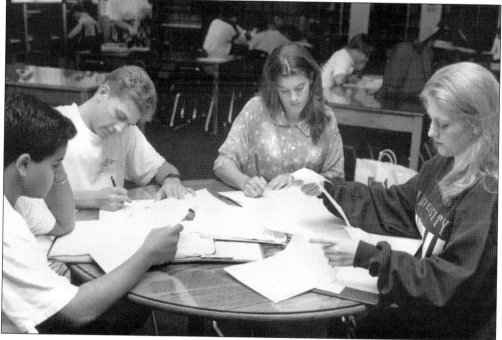

Pictured here are several hardworking students participating in a research roundtable for an International Baccalaureate (IB) course in 1995. Stanton's IB program, started in 1982, was one of the first programs in the state of Florida. It is a demanding pre-university course of study that has earned a reputation for rigorous assessment, giving IB diploma holders the preparation needed to access the world's leading universities.

Pictured here are several images of students in various classroom settings in the mid-1970s. Stanton continued to offer a combination of academic and vocational courses. In 1971, the old Stanton building reverted back to Stanton trustees, and Stanton Vocational High students and courses were dispersed throughout the city to other school locations, with Stanton housing many vocational courses, including service attendants, brick and masonry, food service, tailoring and alterations, service station management, and mechanical/automobile repair. Along with the turbulent times of the 1970s, this was a period of transformation for the school as well: classes expanded; a new principal, Ben Durham, provided new direction; and the faculty and staff became more integrated.

PERMANENT RECORD CARD
NEW STANTON SENIOR HIGH SCHOOL, #153
DUVAL COUNTY — JACKSONVILLE, FLORIDA
Charles D. Brooks, *Principal*

NAME_____ ADDRESS_____ PHONE_____
Last First Middle

Homeroom 10—Teacher_____ Yr.____ Homeroom 11—Teacher_____ Yr.____ Homeroom 12—Teacher_____ Yr.____
Homeroom 10—Teacher_____ Yr.____ Homeroom 11—Teacher_____ Yr.____ Homeroom 12—Teacher_____ Yr.____

Subject	Gr.	Yr.	Cr.	Subject	Gr.	Yr.	Cr.	Subject	Gr.	Yr.	Cr.	Subject	Gr.	Yr.	Cr.
English 1				French 1				Gen. 1				Industrial Arts			
English 2				French 2				Rel. 1							
English 3				French 3				Spec. 1							
English 4				French 4				Gen. 2							
Speech				Latin 1				Rel. 2							
Journalism				Latin 2				Spec. 2							
Civics				Spanish 1				Salesmanship							
World History				Spanish 2				Library Science				Vocational Shop			
American History				Spanish 3											
P. A. D.				Spanish 4											
Twentieth Cent. Prob.				General Business								Driver Education			
Economics				Business Arithmetic								Driver Ed. & Health			
Humanities				Bookkeeping 1								Driver Ed. & Phy. Ed.			
General Math.				Bookkeeping 2											
Modern Math.				Typewriting				Art 1				Bible			
Basic Math.				Clerical Office Prac.				Art 2							
Algebra 1				N-hand & Per. Typing				Art 3				Physical Education 1			
Algebra 2				Shorthand 1				Art 4				Physical Education 2			
Algebra 3—Trig.				Shorthand 2				Occupational Ed. 1				Physical Education 3			
Plane Geometry				Record Keeping				Occupational Ed. 2				Physical Education 4			
				Business Economics				Occupational Ed. 3							
General Science				Business Law				Occupational Ed. 4							
Space Science				Business English				Citizenship 1							
Biology 1								Citizenship 2							
Biology 2				Homemaking 1				Citizenship 3							
Chemistry				Homemaking 2				Citizenship 4							
Physics				Homemaking 3											
Psychology				Modern Fam. Living				Health							

Symbols (o,*) indicate credits earned:_____ School_____
Course_____ Total Credits_____ Grade Point Average_____ School_____

Here are two examples of the progress reports/report cards from New Stanton High School in the 1950s and 1960s. In the photograph above, the extent of the course offerings during the era under Principal Charles Brooks (1953–1968) is seen. Below is a sample report card from a student during the 1969–1970 school year with explicit information about the purpose of these forms as progress reports for the growth and development of students. This information gave detailed instruction to parents as to their role in assisting in the education of their children by being aware of the impression their child was making on school personnel.

This report should be signed by the parent to show that he has read it and should be returned to the home room teacher within three days.
Secret fraternities and sororities are prohibited by State Law.
This card is void if erasures appear upon it.

FIRST REPORT
Signature of Parent *Mrs. Vernell Adkins*
Comments:

SECOND REPORT
Signature of Parent *Mrs. Vernell Adkins*
Comments:

THIRD REPORT
Signature of Parent *Mrs. Vernell Adkins*
Comments:

FOURTH REPORT
Signature of Parent *Mrs. Vernell Adkins*
Comments:

FIFTH REPORT
Signature of Parent
Comments:

Promoted_____ Retained_____

SECONDARY SCHOOLS
GRADES 7 - 12
Duval County Public School System
Jacksonville, Florida

CECIL D. HARDESTY, Superintendent

Pupil's Name *Adkins, Jerome*
Address *1769 Ella Street*
Phone Number *354-0839*
Grade *10*
School *New Stanton Senior High*
Year Beginning *Sept, 19* Year Ending *June, 19*
Home Room Teacher *S. T. Robinson*

Report Cards have as one of their main functions that of maintaining communication between the school and the home. Effective communication between these two chief agencies concerned with the growth of the pupil is vital for his best development.
Fundamentally, the objective of communication between school and home and home and school is that both agencies shall understand the pupil better. Reports from the school to parents have as their main objective letting parents know how the pupil appears to school personnel in the school setting, so that the parents may be better able to:
1. Accept, support, and strengthen the pupil as he meets the problems of growing up.
2. Understand and cooperate in the school's program for the pupil.
3. Adopt realistic and constructive educational and vocational goals for him.

Drew Durham Jr.
Principal

55

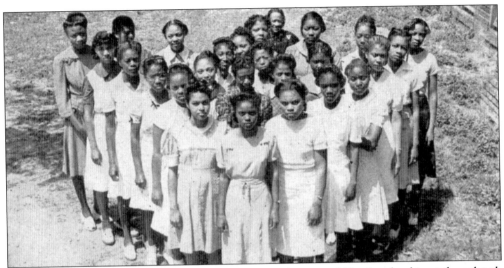

In the 1940s, there were several interest groups students could be involved in at the school. At the time, Stanton had 1,330 students, aged 12 to 22. They could pursue activities in a variety of interest clubs that met regularly from 11:00 to 11:45 a.m. on Wednesdays. As stated by Lucille Coleman, a faculty member at that time, "Every student is where he or she wants to be, doing what he or she wants to do, developing mentally, physically, socially, and spiritually." Of note, many of these groups appeared to be named after recognized leaders in African American history, such as the Mary McLeod Bethune Girl Reserve, the Sojourner Truth Girl Reserve Club, and the Harriet Tubman Triangle (pictured above). Below is a group of Boy Scouts in attendance at Stanton High School in 1941. The Boy Scouts were under the guidance of W. D. Sweet (future evening principal of Stanton Vocational High School), the assistant Scout executive for the Suwannee District. Sweet was known to go "all out" with his assistance in distributing information on the "Buy a Defense Bond" Campaign of the time (supporting wartime relief efforts).

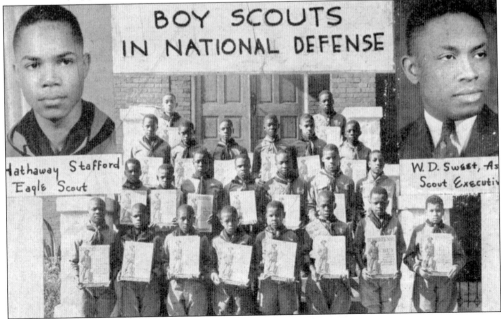

The safety patrol, another interest group for students, was used to assist the administration with keeping order both on and off school grounds (for instance, helping students cross at intersections). These groups participated in parades and community activities, showcasing performing drills, marching routines, and step team performances. Oftentimes these activities were competitive with other organizations or schools. Pictured here are two teams, the "boys patrol" in the early 1940s (above) and the safety patrol in 1957 (below). These particular groups, however, ceased to exist by the 1960s.

The camera club, pictured here in 1949, is another example of a student interest group that served to promote learning as well as help students pursue their careers or personal hobbies. The camera club, for instance, was organized in 1946 by students whose common interest in photography led them to band together for the further study of their subjects. Some members specialized in different forms of photography, such as snapshots. The organization of the club around a hobby and the policy of encouraging members to "learn by doing" were heavily promoted at Stanton as it was thought these clubs were a definite asset to the campus life as well as to individual students.

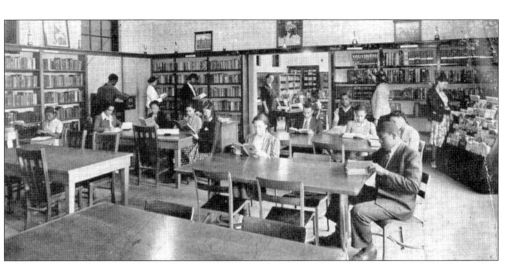

Stanton has always held high academic expectations of its students, from its inception to today. Here students are seen rigorously studying in the school's library during the 1940s (above) and the 1950s (below) in the Old Stanton building on Ashley Street. Throughout the 1950s and 1960s, Stanton was known as an "honors" high school in the state of Florida.

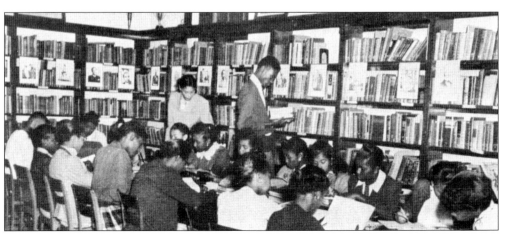

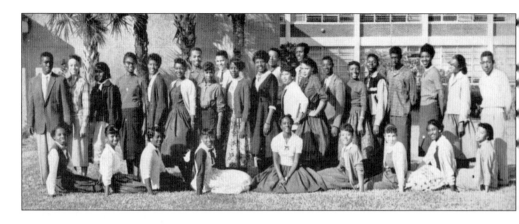

The students of the 1957 New Stanton Senior High School Honor Society (pictured above) are part of a respectable national organization that recognizes and encourages academic achievement while striving for ideals in leadership, character, service, and scholarship. Students are selected and inducted during the second semester of their junior year. Throughout their involvement, they must maintain a minimum grade point average of 3.0 and perform 16 hours service during their senior year in order to graduate as a National Honor Society member. Many students tutor each day before school or take part in after-school campus cleanups that are held throughout the school year. Below is a picture of some of the 220 members of the 2002 Honor Society. Since the 1950s, this chapter was named the Charles D. Brooks Honor Society after then current principal of New Stanton.

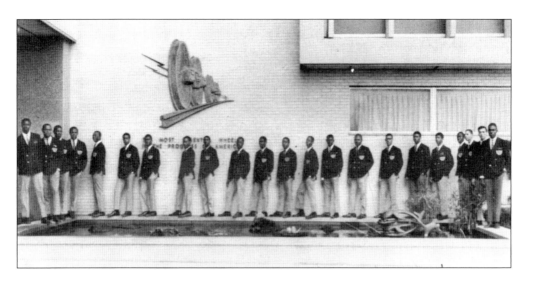

Student clubs of various types continued to expand through the years. In the 1950s and 1960s, there were numerous groups that promoted the development of "strong and positive young men and women" through various means—such as the Esquires and the Esquirettes (pictured above in 1964). In the 1960s and 1970s, many student interest groups began to associate themselves with Greek affiliations or Greek organizations, such as those prominent at the college level. Below is a picture of the Omega Juniors from the 1967–1968 school year. Some of the other groups were Gamma Theta Omega and the Alpha Juniors.

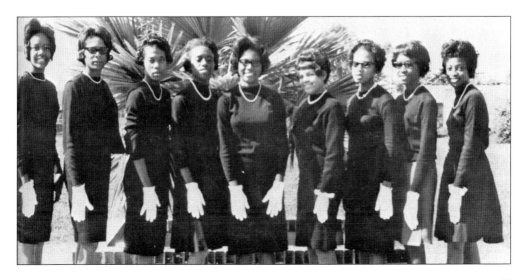

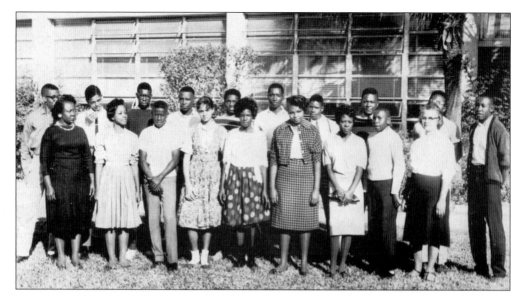

Along with the strong tradition of academic excellence, a number of scholastically oriented student groups have existed through the years. Above is an example, the Mathematics Club of the 1961–1962 school year. Below is a photograph of the 1986 Grand Prix club, which was one of the many groups, like the Brain Brawl, Scholar Bowl, and Academic Decathlon, which competed against other students in the county and state in areas such as literature, drama, history, current events, mathematics, science, art, geography, spelling, speech, and numerous other academic subjects.

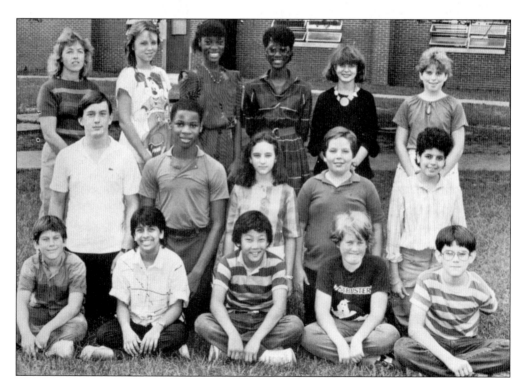

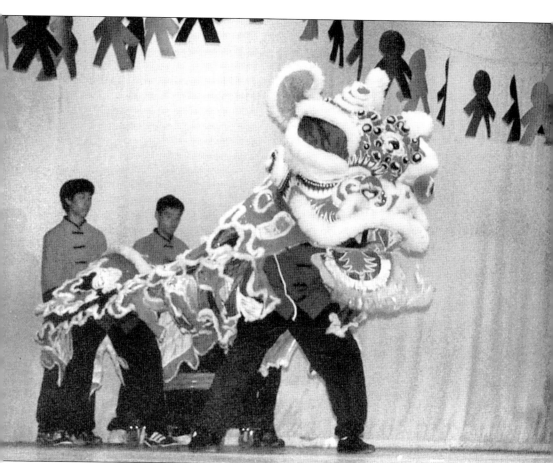

Although Stanton is proudly recognized as an important school in the education of African Americans in Jacksonville, in the 1980s, the school demographics began to change as it moved to a "magnet" status in the school system. Within two decades, the school's focus has expanded to include the promotion and appreciation of diversity within Stanton, as the student body began to reflect this diversity. In recent years, the Multicultural Club has become one of the most popular interest organizations at Stanton. It has representation from every ethnic group within the student body. Yearly, they sponsor activities such as a daytime production for students with an evening performance for parents to attend. Each presentation is standing room only. This club promotes the active exchange and learning of various cultures in a variety of formats.

The *Stantonian* was the name for the annual yearbook as well as the school newspaper for Old and New Stanton. Started by Tolbert Johnson in the 1940s, this paper had an active yearly staff and was used to communicate both world and local events, as well as student events, activities, and, often, opinions or editorial pieces written by the students of Stanton. Later versions of the paper took on different names, such as the *Devil's Advocate*, *Little Devil*, and the *Devil's Disciple*. Pictured at left is the front page from a 1960 *Stantonian* announcing the winner of the Miss Stanton contest. Below is Larletta Galvin (Reddick), a member of the *Stantonian* yearbook staff in 1964.

LEST WE FORGET

September 16 School opened

October 1 First football game

October 3 First broadcast of Stanton's Choral Class

October 16 Miss Stanton Contest ended

November 1 Homecoming Game (Stanton 7—Daytona 6)

November 28 School closed for Thanksgiving

December 20 Christmas Caroling

December 25 Fruit Bowl Classic

January 6 Back to our studies with much enthusiasm (?)

January 10 First basketball game (Stanton 19—E. W. C. 28)

February 3 First Semester ended

February 28 Hi-Y Conference

March 16 Girl Reserves Recognition Service

March 22 Nominations for Who's Who in the Senior Class

April 1 Cotton Cuties Minstrel

April 11 Election of Who's Who in the Senior Class

April 25 All Sport Banquet

April 28 Womanless Wedding

May 5 May Day

June 4 Annual Musical Recital

June 6 Junior-Senior Promenade

June 9 Class Night

June 11 Graduation Exercises

Here is a listing of major events that occurred over the 1940–1941 school year, as listed in the 1941 yearbook. Oftentimes in the "Old Stanton" years, due to factors such as segregation and wartime, the sports teams might play college teams, as seen here for the first basketball game, when they faced Edward Waters College. Also of note on this list are interestingly named activities of which there is not much information, such as the "Cotton Cuties Minstrel" and the "Womanless Wedding," which have not continued through the years. Other items of note are activities that have continued through the years, like the Miss Stanton Contest and the All Sports Banquet.

Featured here are various scenes of the students and school during the 1940s. These collages were originally produced by the yearbook staff for the annuals. At left are pictures of various students or student groups in the 1940–1941 school year. Below are students and classes in 1949. These pictures capture the changes in the makeup of the school population as Stanton moved from having students as young as 12 years old to becoming a high school exclusively.

Here are more student scenes reflecting students gathered on the steps in front of the "New Stanton" building on Ashley Street in 1952 (right) and in the hallway between classes during 1974 at Stanton on Thirteenth Street (below). Notice the contrast in styles—clothing and hair. Despite the passage of time, students today are still seen gathering in the hallways, in the atrium, on the courtyard, and in other various locations on campus before, after, and during school hours.

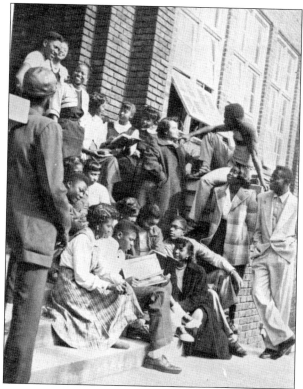

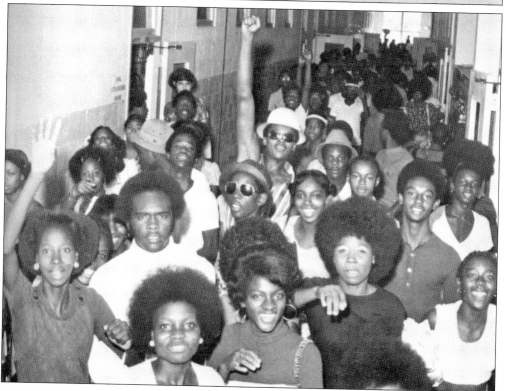

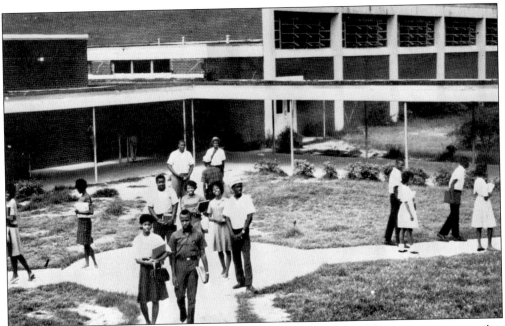

Stanton's campus consists of six buildings, with courtyards and breezeways connecting them all. After several renovations and updates, many of these areas have been substantially changed to accommodate the gathering of students. Here is a picture of students in the 1960s walking between classes.

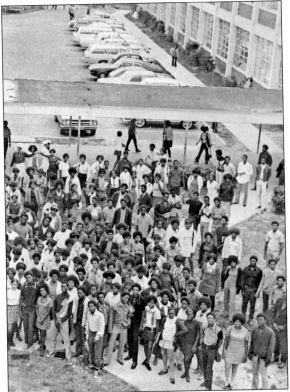

This is the 1979 senior class, shown in an unusual location. This type of photograph demonstrates the "mood" of the times in this unconventional pose—the displaying of solidarity was popular during this time.

At right are individuals selected as the "Who's Who" in the class of 1941. Since the 1920s, it has been customary for the senior classes to choose and vote on several seniors in various superlative categories. These categories have changed through the years, expanding from "Most Popular" and "Cutest" to "Best Smile" and "Most Athletic," or from "Vampire" and "Old Maid" (two categories from the 1920s) to "Still Mistaken For a Freshman" (a 2006 category). The "chosen" individuals have also moved from being voted on singularly to "couple" pairings. A conventional category that remains today is "Best Dressed" as seen in the photograph below from 2002. Of note, this category has expanded to include categories for different forms of dress, like "Never in Dress Code."

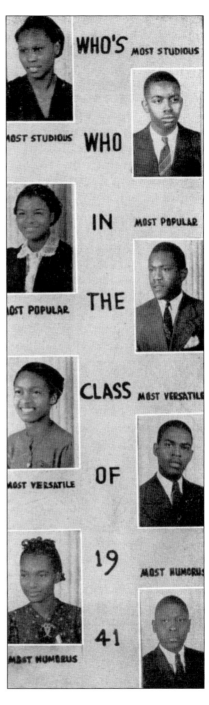

Pictured here is one of the earliest known photographs of Miss Stanton, from 1941. Miss Stanton, a title and position that began in the 1940s, is selected by her peers and crowned in a coronation ceremony during homecoming week. The annual pageant preceding the selection is a well-received student event that provides students, parents, and community spectators with beauty, pageantry, and talent, involving interviews and judging beyond peers in the school. Pictured here is Nancy (Prime) Blossom, who became an earth science teacher at Stanton during the 1960s and at Stanton College Preparatory School in the 1980s. She is remembered as a warm and friendly teacher who taught students how to appreciate the earth as "nature's work of art," not merely rocks and dirt. Through the years, the Miss Stanton category has also expanded to include a "Mr. Stanton" as in the photograph below from 1970 at Stanton Vocational High School. Current students have expanded the pageantry to include titles like "Mr. Ugly," who is selected through a "mock" pageant and crowning ceremony that features male students dressed in formal dresses.

During Homecoming, a tradition since the 1940s, there are activities to celebrate the school—from pep rallies and programs to sporting events like football and basketball games. These activities emerged once Stanton became a high school exclusively. In the 1950s and 1960s, there was a parade featuring the marching and concert band, flags, majorettes, and floats with Miss Stanton and her "court" (as pictured above in 1952). Below is a crowd of cheering fans at a 1968 homecoming game.

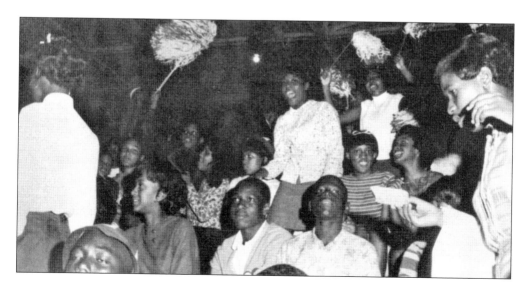

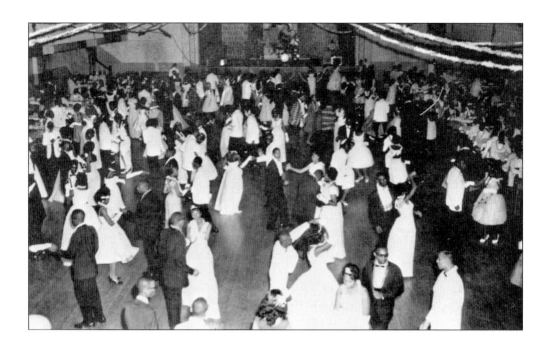

The prom is always a big event for Stanton students, particularly seniors, to get dressed up, dine, dance, socialize, and crown prom queen and king. It is a semiformal (black-tie) dance held at the end of an academic year. In the early 1940s, it was referred to as a "Promenade" and occurred in early June. Here are dancing scenes from the 1964 prom (above) and the 2002 prom (below).

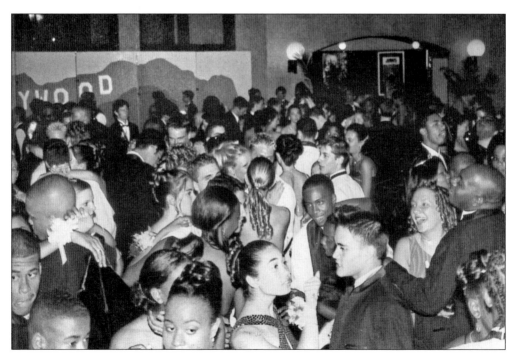

Stanton students are known to hang out at the always-popular beach for picnics, special events, weekend outings, and even photograph sessions, as seen in the above photograph taken in 1974. Below is an image from 1968 at the beach. In the 1960s, students gathered at the beach in places like El Patio, Reynolds, and Evans Rendezvous to dance to tunes coming from the 10¢-a-play jukeboxes, with lots of playing in the dunes and dancing in the streets.

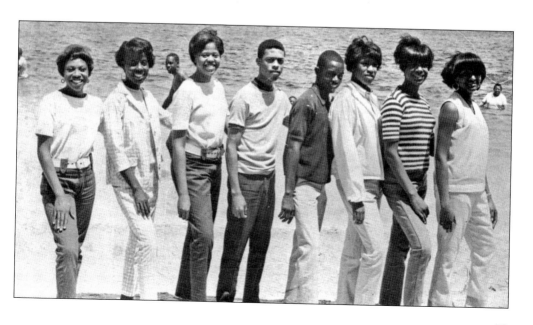

Stanton has always held a prominent presence in the Jacksonville community, and many community members have visited with students or sponsored special events at the school, having connections with Stanton throughout the years. Pictured above is Dr. Arnette Girardeau in 1957. Girardeau was a local dentist in the 1960s and Florida's first African American state senator (in 1982). He was also the nephew of one of Stanton's original trustees who helped to start the school in the 1860s. In this photograph, he is giving free dental checkups to Stanton students, which he did during the 1950s and 1960s. In the photograph below is Roy Wilkerson, a prominent civil rights activist who visited with students at Stanton in 1961 as the city, and nation, was struggling for equal rights for African Americans.

Stanton has remained at its present location for many decades, but its neighboring community has changed. Many local hangouts and businesses that once existed for Stanton students have come and gone. One fondly remembered business was Brink's Confectionery, run by A. L. Brinkley in the 1950s and 1960s, as pictured here. It was the "store next door" where students could meet and buy school supplies. Students fondly remember buying hot dogs, soda water, and two-for-a-penny cookies that were available in large "Tom's" jars. Brink's was not as popular as the Roosevelt Grill on Ashley Street, near "Old Stanton," where students loved the hot dogs with slaw and hot French fries with hot sauce in a paper bag, but clearly more convenient, as it was next door to the school on Thirteenth Street.

In the 1980s, when Stanton reemerged as Stanton College Preparatory School, with a change in curriculum as well as student demographics, the school adopted another mascot in addition to the "Blue Devil." The "Phoenix" became a symbol for the school's new beginnings. In the photograph at left is the "Phoenix" at a pep rally in 1993. Both of the symbols remain active representations of Stanton's pride and accomplishments. As seen in the school's emblem below, there are images of both the blue devil and the phoenix along with symbols for scholastic achievement.

Four

THE SPORTING LIFE
ATHLETICS

Although it had been recognized as a high school of academic excellence for decades, Stanton students also excelled in sports and athletic competitions. In fact, because Stanton had such high excellence in both academics and athletics and had been in existence for decades, competitions that would not normally have allowed African American students to participate were opened and provided opportunities for students to face competition in various academic and community arenas from the 1920s through the 1950s. Through the years, the extent of the competition that Stanton faced continued to grow, while the achievements in these competitions were commendable as well. Pictured here is coach James P. Small photographed among numerous awards and trophies won by the sports teams in 1960.

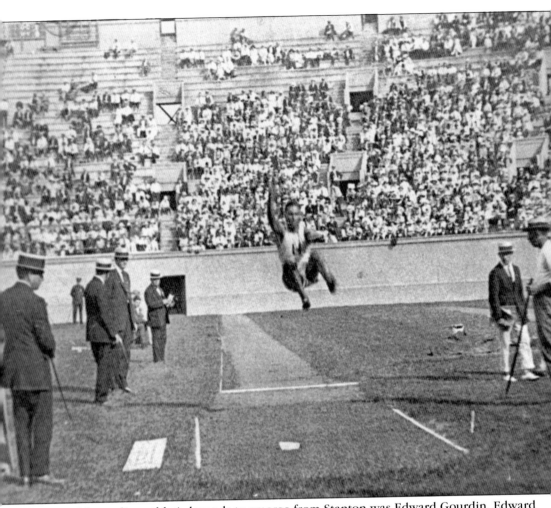

One of the earliest athletic legends to emerge from Stanton was Edward Gourdin. Edward Gourdin was the 1916 class valedictorian at Stanton High School. In 1921, he became the first man in history to make 25 feet in the long jump, and in the 1924 Olympics, he won the silver medal in the event. He attended Harvard, earning a law degree in 1924 while also being recognized as a track star at the university. This photograph features Gourdin accomplishing the World Record of 25 feet, 3 inches on July 23, 1921, during the dual meet between Harvard-Yale and Oxford-Cambridge held in Harvard Stadium. He also won the 100-yard dash on that day, defeating a future 1924 Olympic champion. In later years, Gourdin retired from the U.S. Army with the rank of brigadier general—a first in Massachusetts for an African American. In 1958, he was sworn in as the state of Massachusetts's first African American Superior Court judge. Gourdin's life accomplishments are notable and exceptional, both in magnitude and in the fact that he was able to break several color barriers in every arena in which he excelled.

ATHLETICS

FOOTBALL
Review of 1924 Season.

The 1924 Football season opened at Stanton with all the old men except three; Braden, and Slaughter our star ends, and Anderson a stellar guard. Braden and Anderson were graduates of 1923, and Slaughter transfered his talents to another school.

Coach J. P. Harrison realized what a difficult problem it was to find two good ends. This problem was solved when Mitchell and Chisolm came t ous from F. A. M. C., and with much practice and lots of instruction filled these position.

Coach J. P. Harrison subjected the boys to hard practice in preparation for the first game, which was with Florida Normal and Industrial Institute. Our boys were in mid-season form, and defeated the boys from F. N. I. & I. 54-0. The real test for the wearers of the blue and white came when they met Edward Waters College. This was the best game of the season. Our boys proved to be too much for the College boys, and when the final whistle blew the score stood 19-0 in favor of Stanton.

Our next game, which was with Cuyler High of Savannah, proved to be a walk away for our boys, ending with the score 72—6, in favor of Stanton. In this game our goal line was crossed for the first time in three years.

WILLIAM HARRISON.
Athletic Editor.

Stanton began playing football in 1911 when a senior named Lawrence Brown got permission from Principal S. P. Robinson to form a football team. According to the history of the Florida Interscholastic Athletic Association, the team Brown formed was the first black high school football team in the state. It was not until 1918 that Stanton played its first real high school team—Gainesville's Lincoln High School. The score was Stanton 81, Lincoln 0. Details of the 1924 season are highlighted in the image above (taken from the 1924 yearbook). During this period, there were few high schools for African Americans to play football, so Stanton often played teams from the area colleges like Edward Waters, Florida A&M University, and Bethune-Cookman College. Also featured in this review are highlights from the 1924 baseball season, claimed to be one of the best teams in Stanton's athletic history (below).

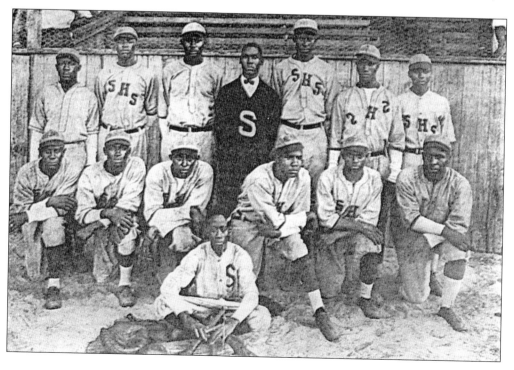

FOOTBALL

By BEN LEROY ROBERSON

The clouds overhead are in a daze. The atmosphere is cool. The masses of people along the most popular streets of colored Jacksonville, (Ashley, Broad and Davis) seem to murmur something. I wonder what it is? I gazed into my crystal. It looks like a ball, it is a leather casing about a foot long and seven inches in diameter, enclosed and inflated rubber bladder. Now it is clear, by Webster's definition, it is a football. I'm just a bit poetic——

> Now take that tough center,
> Whom that line was built 'round,
> When he shoots that ball behind him,
> The backfield goes to town.

That reminds me, with your permission I will attempt to present Stanton's senior members of the 1936-1937 football squad. Do you remember the expression, Paul Revere rides again? Now Ben Roberson speaks again. My exact position now is on the corner of Broad & Ashley streets. Who goes there? It's I, Captain Red "Wimpy" Rozier. Well, well, there goes a proud fellow, who is capable of wearing the title captain.

Who? lo, Oh! here comes a pine tree. Ha! Ha! Ha! excuse me folks, it's Geo. "Trickshot" Washington, a demon, if there ever was one, he plays end on the football team.

Look who's here. It's Ernest "Inky" Wilson. Gang, do you remember this? "You don't think I would"

Carl "Smackup" Blackwell, the pivot man for the squad.

Sumner "Fatty" Wiles, the boy who offered plenty of opposition at end.

Charles "Full Tog" Bivins, in true form the tractor of the backfield, is that correct Sharlie?

"Nana-Boat-Red" All State guard, is another way to say Jack Manning around Stanton High—I couldn't forget this. "Easy Tee Hound."

Jean "the Cat" Downing, a fellow student; the class president and also a football star.

William "Buster" Isham, the one and only elusive man in the backfield.

Willie "Big Bill" Thomas, the ironman of the forward wall and last but not least Ben "Sick Boy" Roberson just another number in the backfield to make four.

You know something, my friends, my introduction of the senior teammates has ended, but to conclude this article without mentioning the coach would be terrible, so I want you all to know Coach "Bubble-Up" Small. It isn't surprising to say I think he is a swell guy. As you know, I (Ben Roberson) am a gentleman of leisure, not a scholar—So I will take time out to recuperate. I'll be seeing you——

When Stanton football began, the team was originally known as the Tigers in pink and gray, the same colors and nickname as Jacksonville's only white high school before 1927. Football games, like the rest of society during that time, was segregated. By the 1920s, under coach J. P. Harrison, the team changed to the colors blue and white. From 1926 to 1933, under the direction of Fred "Frog" Herndon, the football team changed from the Tigers to the Tornadoes. James P. Small, a former player at Stanton under Coach Herndon, took over as coach in 1934 and ultimately changed the name to the Blue Devils, Stanton's current team nickname and mascot. In this write-up feature from the 1937 yearbook, Small is referred to as "Coach Bubble-Up"—later to be known as "Bubbling." The write-up featured highlights from the 1936–1937 football season.

Here are some of the earliest photographs of the athletic teams featured in the annual yearbook—the 1940–1941 football and 1940–1941 girls' basketball teams. In that year, the football team had a 7-6 record playing teams from Florida, Georgia, and even Charleston, South Carolina. That year, the boys' and girls' basketball teams went to the district championships with a 16-3 season record for the boys' team and an 11-8 record for the girls' team. The basketball teams played other African American teams from around Florida, high schools and colleges, and from Savannah, Georgia.

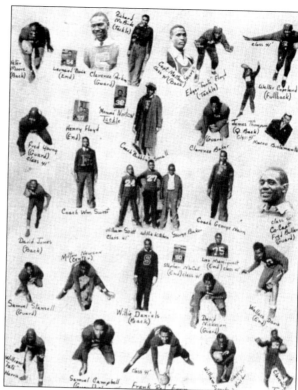

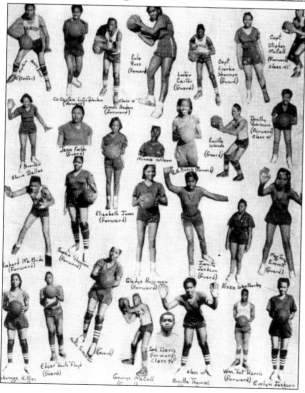

Athletics were thriving by the 1950s; pictured here are the 1952 basketball team (above) and the football team (below). That year, the football team was the Big "12" Conference Champions and City Champions, denying four out of nine opponents the opportunity to score. Featured in the picture below in the last row are the coaches James P. Small (back row left) and Ted "Shot" Montgomery (back row right).

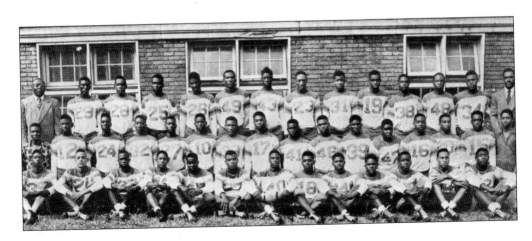

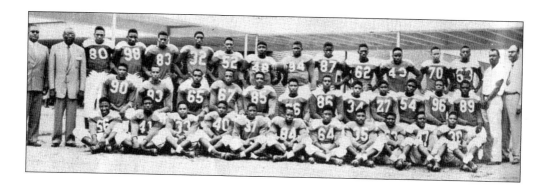

In 1954, the football team (pictured above) had another winning season, with a notable homecoming victory where they won 19-0. Below, the team is photographed as they board a bus for travel to an away game. Teams often traveled throughout the state for competition with other African American teams. In Jacksonville, at the time, there were only two public high schools for African Americans, Stanton and Gilbert High School, which opened in 1947. Though Gilbert was a natural rival for a Stanton, the two teams did not compete until 1949.

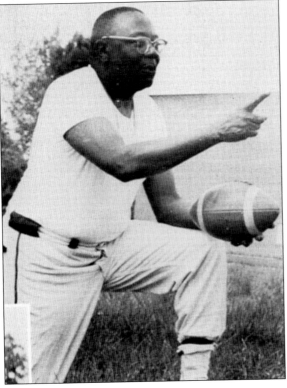

The 1954 group shot above features coaches James P. "Bubbling" Small (left) and Shot Montgomery (center) as well as Ike Grayson (right). Coach Small, the head coach, was known as the "Dean of High School Coaches" in Duval County during the 1950s and 1960s. He coached at Stanton from 1934 to 1967, winning more games than any coach in Jacksonville high school history. He led the Stanton team to eight Florida Interscholastic Athletic Association North titles before 1950, including the 1944 Class A High School football champions (the high-scoring team for that season with 379 points), the 1949 Stanton "49ers" State Football Champions, and the 1952 Conference Football Champions. He also led the team through an unbeaten season in 1957. In 34 years of coaching, he had only five losing seasons; his overall record was 197-84-25. Small is pictured at left in 1964.

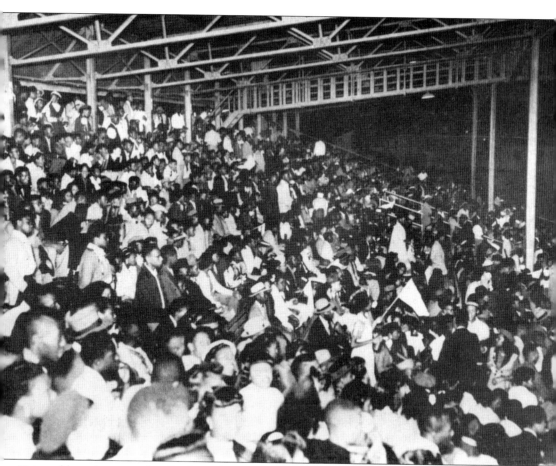

Pictured here is a crowd at Durkeeville Ball Park during a night game in 1952. Durkeeville, also referred to as the Myrtle Avenue Ball Park, looms large in African American history in Jacksonville as it was home to the Jacksonville Red Caps, part of the Negro Baseball Leagues. In the 1910s, the park was known as Barrs Field, the site used by the only African American baseball team, the Jacksonville Athletics (a team on which James Weldon Johnson played). By the early 1950s, Stanton practiced and played its football games there up until the late 1960s, when integration brought different teams and locales for football competitions. By the late 1970s, the park was experiencing major decline and was slated for demolition. However, in the 1980s, councilwoman Sallye Mathis sponsored legislation to renovate the stadium and rename it in honor of Stanton coach James P. Small, who died in 1975. In 1985, the renovation was completed and the park was newly named the J. P. Small Memorial Park, as it stands today. Today it is a historical site featuring a small museum.

OFFICIAL PROGRAM

STANTON SENIOR HIGH

Vs.

MATTHEW W. GILBERT

GATOR BOWL
7:30 P.M.

The East-West Classic, a popular season-ending game for Stanton, was "born" in 1948 at the Durkeeville Ball Park. At this time, the junior varsity team of Stanton played the eighth- and ninth-grade team from Gilbert High School. In 1949, the 10th grade was added at Gilbert, giving it senior high school status, and the first varsity high school game was played during that year. The East-West Classic received its name from the location of the two schools at that time: Gilbert High of the east and Stanton of the west. In 1950, on Thanksgiving Day, the game was moved to the Gator Bowl—a momentous event. From 1949 to 1969, Stanton and Gilbert each won eight games, with four games ending in a tie. The Classic games ended with integration and the change of Gilbert back into a junior high school. The Classic was revived briefly in the 1970s for games between Stanton and Raines High School but without the same fervor. At left is a picture of the official program in 1961, and below is a copy of the team photograph and roster for that year. (Both courtesy of Carolyn Conway Sommerville.)

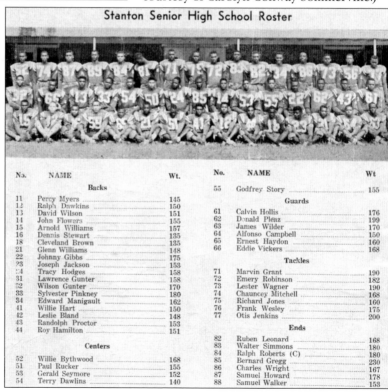

Stanton Senior High School Roster

No.	NAME	Wt.	No.	NAME	Wt
	Backs		55	Godfrey Story	155
11	Percy Myers	145		**Guards**	
12	Ralph Dawkins	150	61	Calvin Hollis	176
13	David Wilson	151	62	Donald Pleaz	199
14	John Flowers	155	63	James Wilder	170
15	Arnold Williams	157	64	Alfonso Campbell	150
16	Dennis Stewart	135	65	Ernest Haydon	160
18	Cleveland Brown	135	66	Eddie Vickers	168
21	Glenn Williams	148			
22	Johnny Gibbs	175		**Tackles**	
23	Joseph Jackson	153			
24	Tracy Hodges	158	71	Marvin Grant	190
31	Lawrence Gunter	158	72	Emery Robinson	182
32	Wilson Gunter	170	73	Lester Wagner	190
33	Sylvester Pinkney	180	74	Chauncey Mitchell	168
34	Edward Manigault	162	75	Richard Jones	160
41	Willie Hart	150	76	Frank Wesley	175
42	Leslie Bland	148	77	Otis Jenkins	200
43	Randolph Proctor	153			
44	Roy Hamilton	151		**Ends**	
			82	Ruben Leonard	168
	Centers		83	Walter Simmons	180
			84	Ralph Roberts (C)	180
52	Willie Bythwood	168	85	Bernard Gregg	230
51	Paul Rucker	155	86	Charles Wright	167
53	Gerald Seymore	152	87	Samuel Howard	178
54	Terry Dawlins	140	88	Samuel Walker	153

Although it was primarily a school for preparing trades or offering pre-college courses, with a student body that included older, working adults in the evening, Stanton Vocational High School had an active athletic program. The school's monikers were the Engineers and the Rams (evening). Stanton Vocational basketball teams during the 1950s and 1960s played teams from Georgia and several cities within Florida. Oftentimes, the team would play against other Adult League teams, not solely high school—particularly since the school had an active evening program. Interestingly, because there were active athletic teams at both Stanton high schools—New Stanton and Stanton Vocational High School—during the 1960s, often the two schools would meet in competition. On this page are several images from Stanton Vocational High School. In the photograph at right are several action shots from the 1962 basketball and football teams. Below is a picture of the 1962 "Rammerettes," the girls' basketball team from the evening school.

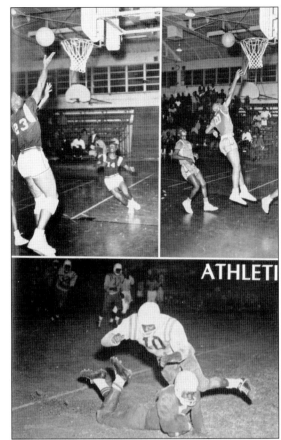

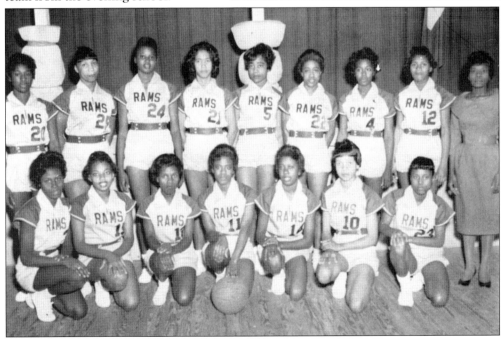

OUR VARSITY BASKETBALL TEAM

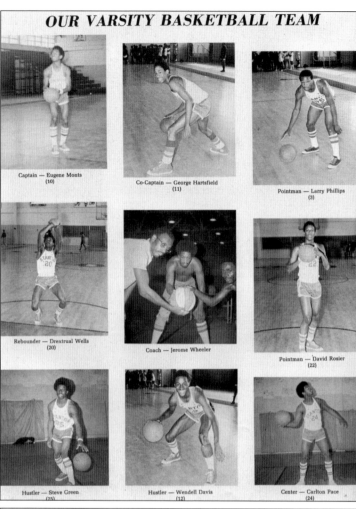

Captain — Eugene Monts
(10)

Co-Captain — George Hartsfield
(11)

Pointman — Larry Phillips
(3)

Rebounder — Drextrual Wells
(20)

Coach — Jerome Wheeler

Pointman — David Rosier
(22)

Hustler — Steve Green
(25)

Hustler — Wendell Davis
(12)

Center — Carlton Pace
(24)

In the 1970s, Stanton Vocational High School closed and Stanton High School took on much more of a vocational focus. Yet athletics continued to thrive. At left is a featured spread on the varsity basketball team that appeared in the 1972 yearbook. That year, the team entered the season ranked third in the Gateway Conference and went through the season with a 16-5 record with narrow losses (no more than 4 points) to Fletcher, Lee, Sandalwood, and Forrest High Schools. Below is a photograph of the 1972 baseball team called the "Batting Blue Devils." They were coached by Ken Longmire and Leo Christie that year.

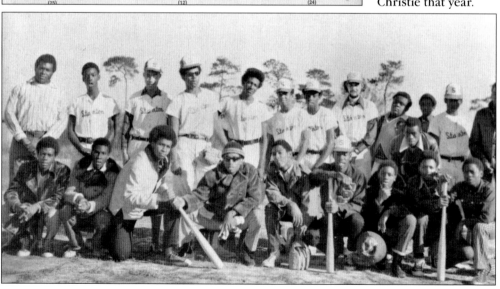

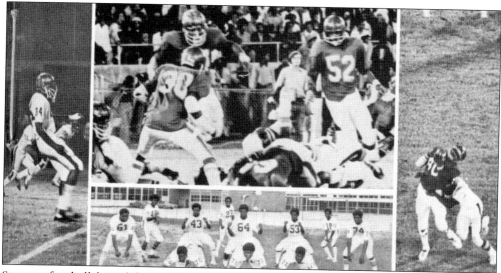

Stanton football lasted from 1911 through 1980 with a record of 252-186-31 from 1911 and 1925–1980 (the records for the 1912–1925 seasons are unknown). They won city championships in 1949, 1950, 1951, 1952, 1957, 1959, and 1962. The known coaches throughout the years were Lawrence Brown (1911), James James (1912–1914), George Sampson (1917–1920), W. H. Harrison (1921–1924), Fred Herndon (1926–1933), James Small (1934–1967), Jimmie Johnson (1968–1969), Harold Hair (1970), Carl Hughes (1971–1976), Nathaniel Farley (1977–1979), and Robert Wilcox (1980). Stanton dropped football after 1980 and restarted the program in 1998 under Freddie Stephens. In the photograph above are images from the 1973–1974 season of football. In the photograph below is a scene from the first homecoming game played on Stanton's own field against Fernandina in the 2001–2002 season.

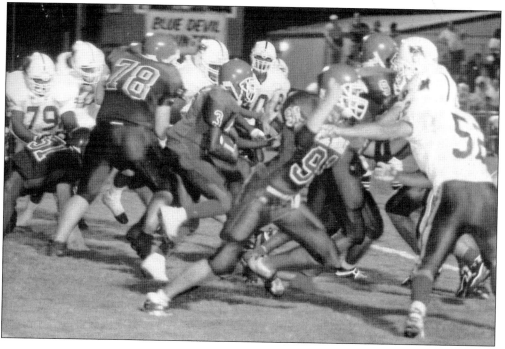

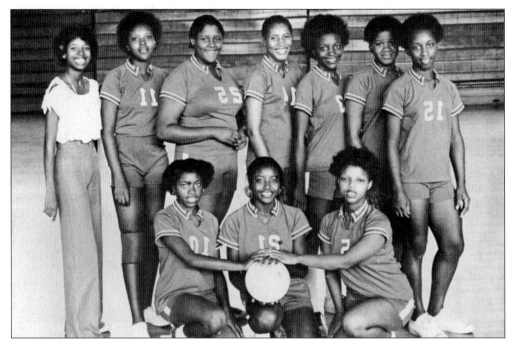

During the 1970s through 1981, Stanton continued to expand its athletics to include more sports beyond the traditional teams of basketball, football, baseball, swimming, and track and field. New teams like volleyball emerged, as shown here in 1979.

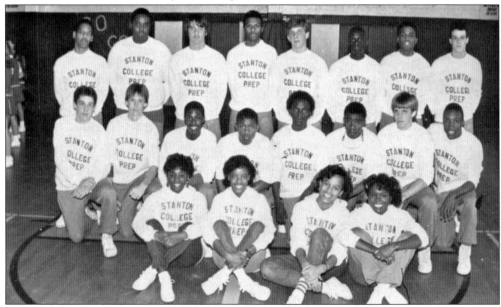

When Stanton College Preparatory School opened, there was no official athletic program beyond physical education. In 1986, the school participated in its first "interscholastic intramural" basketball game. A group of intramural players coached by James Daugherty played against a similar squad from Edward H. White Senior High School, with Stanton winning 46-42 in overtime. This game was preceded by SCPS's first athletic pep rally as well. Pictured here is the team, including managers and statisticians.

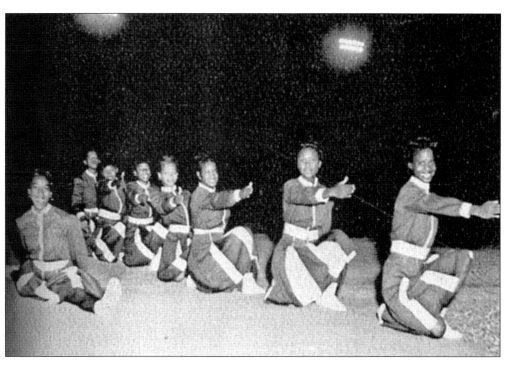

In the early years of Stanton and New Stanton, cheerleading held a traditionally supportive role for the sports teams and events, as it was one of several groups within the school that helped to promote school spirit and pride (pictured above in 1954). Beginning in the 1970s, cheerleading began to become competitive, with students participating in events for recognition and awards. Currently referred to as varsity cheerleading, it is now considered a real sport requiring hours of weekly practice. The Blue Devil cheerleaders, pictured below in 1993, have achieved recognition and awards through the years.

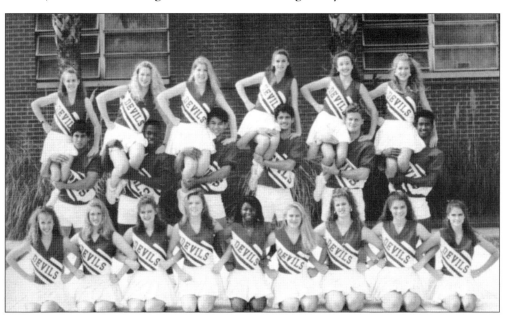

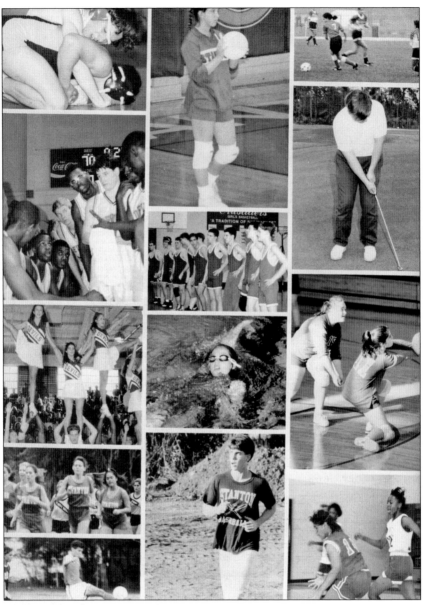

Stanton College Preparatory School started in 1981 as a magnet school with a focus on academics for grades 7 through 12. In 1989, varsity sports reemerged at Stanton. In 1993, Stanton added competitive teams like wrestling, women's soccer, and track and field. From then through the present, different sports were offered to the student body as the enthusiasm of the teachers and coaches translated into success for the players. Pictured here are scenes from the expanding sports activities at Stanton College Prep in 1993. Stanton sports teams now include rowing, soccer, tennis, swimming, wrestling, golf, softball, volleyball, track, cross-country, and lacrosse, along with baseball, basketball, and football, which have been around at Stanton most consistently through the years. Most of these teams win competitive awards and distinctions, as Stanton athletes are known to be a group of hardworking athletes, representative of the Stanton tradition of excellence and high standards that extends from academics to athletics.

Five

CELEBRATING THE ARTS
ART, DRAMA, AND MUSIC

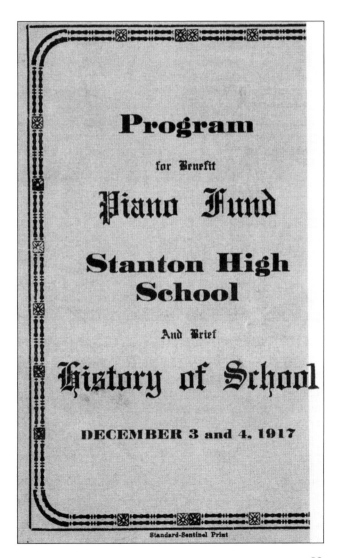

Whether it is visual arts, drama, choral singing, or band, Stanton students have long enjoyed a tradition of strong arts and music programs. Back during the "rebuilding" of Stanton in 1917, there was a Piano Fund Program held in order to support the music department of the school at that time. Pictured here is the cover of the program for this event, which featured Mary McLeod Bethune delivering the address that evening. The event consisted of various solo (both vocal and instrumental) and choral performances along with a few dance performances featuring Stanton students and faculty. Mrs. J. A. Butler and Prof. J. M. Robinson were the directors of music at the time.

A Pictorial Collection Celebrating the Arts
Volume II

Art

M. Hampton
V.L. Hart
Carolyn Fooshee
Joi Roberts
Susie Lyman
Geraldine Leigh

Drama

R.L. Hierrezuelo
Amy Curry
Mrs. Keyes
Toni Preston
Joey Roper
Jeff Grove
Chester Donne
Shirley Sacks

Music

K.D. McFarlin
M.L. Butler
Lloyd Pearson
A. West
R. Nathaniel Dett
H. Lane Wilson
W.T. Harper
Henry Ward Jenkins, Jr.
Tolbert Jackson
D. Avery Hampton
E. Graham
C.M. Buggs
D. Walker
Larry Barefield

V. Brown
Ernest White
Kathryn LaRosa
James Smith
Susan Arnold
James Kitchen
J.P. Small
A.M. Espy
A.H. Moore
Marcus Young

In 2008, the Cultural Heritage Committee's Annual Luncheon celebrated and honored the arts programs at Stanton through the years. As a part of the luncheon, a historical book was produced for distribution to the attendees, with an assortment of photographs of bands, music programs, and arts and drama productions through the history of Stanton. In this book, as shown in the image here, was a listing of the talented faculty that had worked at Stanton in the various arts areas through the years.

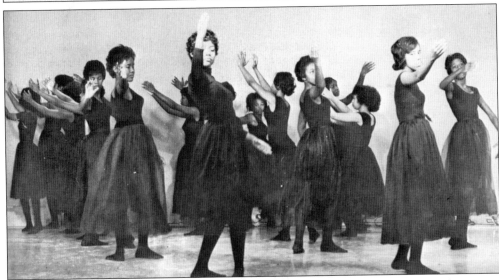

Featured here are students from 1964 dancing in a recital performance at the school. Dancers were often featured in such performances or along with the marching and concert band at different events. The dance program continues to thrive at Stanton College Preparatory School today in various genres and formats.

Visual arts at Stanton have always excelled as the academically talented students showcased their strengths in drawing, designing, sculpting, and more. The arts department, referred to now as a part of the aesthetics department at Stanton College Preparatory School, has always encouraged the talent in students through classes as well as local and regional competitions. There is now an "art niche" at the bottom of the east and west wing staircases of the building that showcases artists' talent and is updated throughout the year. Pictured here are two classes on a field trip to observe and learn from art on display at the Cummer Art Gallery, in 1962 (above) and in 1993 (right).

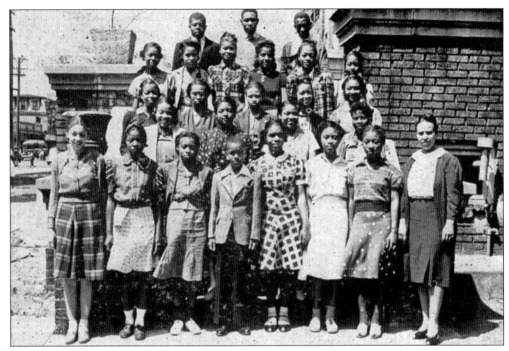

Stanton has had a long history of students interested in acting in or the production of plays and performances. Drama at the school was envisioned as a study of the art of acting, directing, dance, music, and design—particularly as the type and magnitude of productions grew over the years. In the 1940s, the drama club was called the Mask and Wig Club, seen in the photograph above with their club sponsor and director Amy Stewart Currie (first row, far right), who served in this capacity for several decades (at both Old and New Stanton). The drama club was always popular, as seen by the large number of members in the 1983 photograph below. Drama students worked on individual skills as well as how to work as a company when producing plays. They often considered themselves to be like "one big family," as remarked in the 1983 yearbook featuring this drama club photograph.

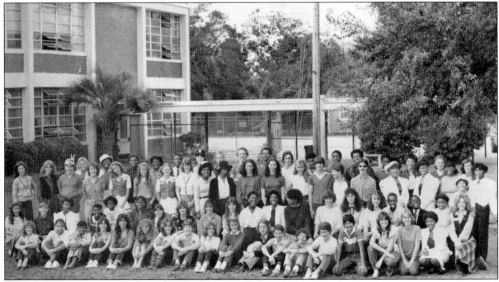

The photograph at right is a scene from a play rehearsal in the 1960s. The play is unidentified, but the director was Amy S. Currie. Below is a picture of Amy S. Currie (left) receiving recognition at her retirement banquet in 1968 after more than 40 years of service as an English and drama teacher. Another notable drama teacher during this time was Coatsie Jones, who worked from the 1940s through the 1960s.

This photograph shows a scene from the 1957 production of *Carmen* performed by the Stanto-Musi-Cho, a choral and performance group that existed in the 1950s and early 1960s under the direction of A. M. Espy. The performance was a highlight of the year with complete and colorful costume and set designs. Below is a photograph featuring a scene from another colorful production by Stanton students in the 1970s: the 1979 production of *The Second Marriage of Santa Claus*.

Here is a photograph of students singing in a production of *Rock-n-Roll*, the major musical produced and performed by the drama club in November 1982 in Stanton's auditorium. The play was directed by Toni Preston and Derrick Davis. While the major musicals for each year have varied, typically the drama club will participate in other school events, such as Open House and Christmas programs.

This scene is from the 2006 production of *The Taming of the Shrew*, produced by the Thespian and Drama Clubs, who work hard throughout the year to put on several plays. Again, these students do more than act, as several write, direct, and work heavily behind the scenes. Currently Stanton's Thespians Club is recognized as top in the state and includes many students who have been selected into the International Thespian Society.

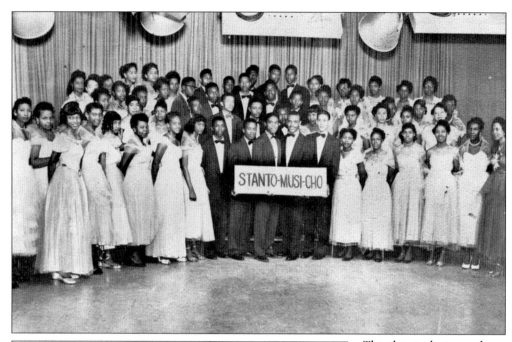

The above photograph shows the Stanto-Musi-Cho choral group in 1954 as they were featured in a television broadcast. This group was one of the two choirs at Stanton in the 1950s. They ranked high in regional and state music festivals and performed at civic and church events. For several years, they were favorites at the famous Suwannee River Music Festival in Live Oak, Florida. The State Archives of Florida have a film featuring this group. At left is a photograph of A. M. Espy, one of the directors of Stanto-Musi-Cho, who is fondly remembered by past students. After Espy moved into an administrative position, O. R. Smith directed the group until its last year of existence in 1961.

At right is Alpha Hayes Moore, the first chorus director at Stanton. Her music career spanned 40 years in which she enriched the lives of both Old and New Stanton students, molded talented artists, and helped to build knowledge and character through her direction of the Glee Club. A 1919 graduate of Stanton, Moore was the founder of the Florida State Music Teachers Association, which was the first music educators association for African Americans until it merged with the all-white Florida Music Educators Association in 1967. During her tenure as the choral director at New Stanton, she maintained one of the finest choruses in the state that earned consistent superior ratings at district and state finals. Under her directorship, the chorus widened their scope and exposure with extensive trips to Washington, D.C.; New York; Delaware; Pennsylvania; and twice to Nassau, Bahamas. Below is the Glee Club under Moore's direction as they performed at a church service at Ebenezer Methodist Church in 1961.

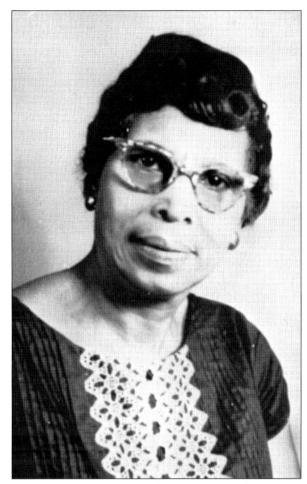

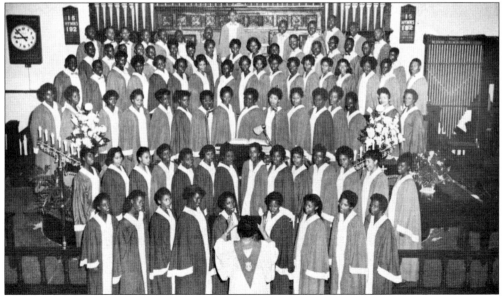

In the 1950s and 1960s, there was a day and evening choral group at Stanton Vocational High School. Pictured here is the 1966 day chorus on the steps outside of the Ashley Street building.

By the 1970s and 1980s, choral groups at Stanton expanded to include different groups beyond the Glee Club, such as a Gospel Choir and the "Voices of Stanton," pictured here, which lasted throughout the 1990s.

Pictured here is the most notable and the first official band director of Stanton, Kernaa D. McFarlin. He is the first African American elected to the Florida Band Association Hall of Fame. About 2,000 students completed McFarlin's music program, and almost half of these students received "Superior" ratings in band contests. Because of his leadership and direction, many Stanton graduates went on to become high school and college band directors, including C. Buggs, who replaced McFarlin in 1967–1968 and continued to drive the band in the same direction of accomplishments. McFarlin's achievements are best summed up by his former students, who lovingly refer to him as "Mr. Mac" and reflect on his teaching of music as well as character and Christian values for successful living. In the photograph below, he is talking with two of the Florida A&M Band directors at the Gateway Classic in 1964.

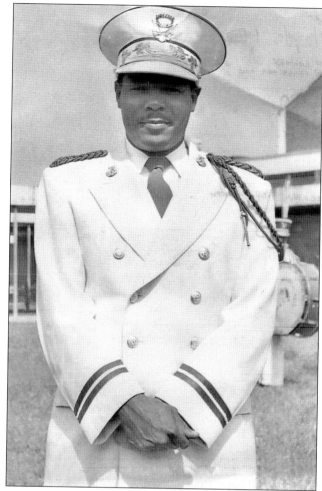

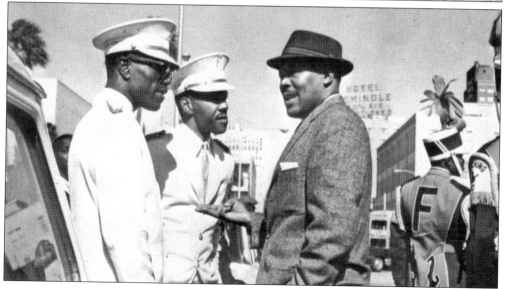

Florida Band Directors Assn.
AWARD
ANNUAL BAND CLINIC HELD AT
MIDDLETON HIGH SCHOOL, TAMPA, FLORIDA
APRIL TWENTY, NINETEEN HUNDRED AND FIFTY

STANTON SENIOR MARCHING BAND

CLASS DIVISION

L. A. Kirksey M. A. Rodriguez D. H. Hill
PRESIDENT VICE PRESIDENT TREASURER

Under Kernaa D. McFarlin, Stanton bands achieved extraordinary artistic success, including superior ratings in marching, concert, and sight reading at state competitions for 19 consecutive years. The band has been recognized in several domains for their high level of performance by many college music educators as well as the Jacksonville community. Seen above is an early award achieved by the band in the Florida Band Directors Association Band Clinic in 1950. Below is a photograph of the 1952 Stanton Marching and Concert Band. In 1957, the Stanton Band was the first all-black Florida Association of Band Directors Band to enter and achieve all superior ratings in Class AA.

MESSAGE FROM THE DIRECTOR

You are now being considered as a prospect for the "Marching Blue Devils" Band. The history of the Blue Devils is a long and glorious one. The good reputation of the Band has been earned by much hard work, self-sacrifice, and sincere devotion on the part of many fine boys and girls. You have every right to feel proud of your accomplishment, because membership in the New Stanton Senior High School Band means enjoyment of rich musical experience.

Every good Band has high standards and takes pride in its work. These traditions and standards can be maintained only if each member resolves to do his best to improve constantly. The responsibility is yours to continue to improve in tone quality, and technical ability. Take pride in your organization and follow the rules and regulations listed herein. Always remember that good character and scholarship supercede our finest musical objectives. Good luck and sincere wishes for your success in the Band.

Your New Band Director

Kernaa D. McFarlin

Throughout the 1950s until the late 1970s, the members of the New Stanton Marching and Concert Band, the "Marching Blue Devils," were expected to adhere to strict principles and high standards for conduct and performance. These two images are taken from the 1960 Band Handbook, which was distributed to all band members with specific information about expectations, organizational rules, procedures, band inspection guidelines, and even dress codes for "away" performances. The high standards had, no doubt, an impact on the band's success and accomplishments over the years. The handbook opened with an inspirational message from the director, "Mr. Mac" (above), while it also gave information on the performances and projects that the band participated in regularly, which, as one can see, were numerous and statewide (see below).

ANNUAL BAND PERFORMANCES AND PROJECTS

Six Home Football Games Including:

Homecoming
Douglas Anderson - Stanton game
Northwestern - Stanton game
Mathew W. Gilbert game

Downtown Community Chest Parade
City Wide Veterans Day Parade
Urban League Parade
Florida Classics Parade
Band Parents "Ye Olde Country Frolic"
Out-of-town trips accompanying our team
Bethune Cookman College Game and Parade
World's Finest Chocolate Candy Sales
Annual Spring Concert
District II Band Festival
North State Band Festival
Exchange Band Concert with
 Blake High School of Tampa
 Jones High of Orlando

Concert - Albany State College
 Albany, Ga.
County Music Festival
Commencement Activities

In addition to this, the Band plays an average two additional parades yearly, and perform at "pep" rallies, chapel programs, and night community programs.

—*—

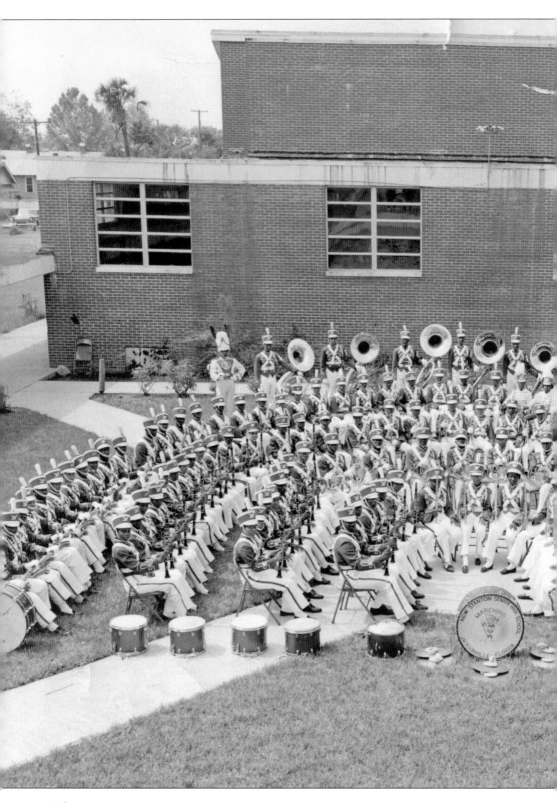

Here is a photograph of the 1961–1962 Stanton Marching and Concert Band. This band performed in numerous parades and festivals across the state, with additional performances at civic and community events. As seen here, the typical size of the band was at least 150 members, with approximately 40 members graduating each year; over half of these received scholarships to attend college and universities nationwide.

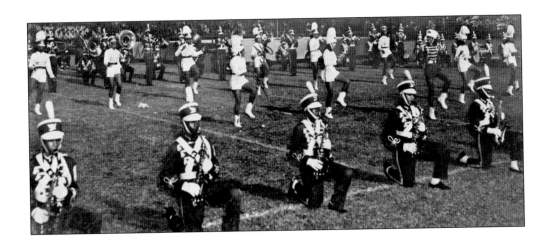

During the 1960–1961 school year, the Stanton Marching Blue Devils participated in the Annual Gator Growl Celebration held at the University of Florida in Gainesville. The popular group of fast-stepping and highly precise musicians was seen by an estimated 100,000 people as the band was featured and televised for approximately one half hour. The performance was considered a big hit by the Gainesville and Jacksonville communities and a source of pride for the band's director, Kernaa McFarlin, and the Duval County Music Program. The above image is from the band's performance, featuring the saxophone section, of which Ronald Galvin can be seen fourth from the left. Below is a photograph of the majorettes at this event, with Grace Brown (Galvin) in the center as head majorette. The majorettes during the 1960s were also award-winning in twirling competitions throughout the state.

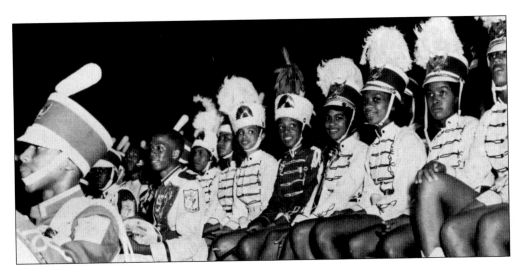

In addition to its marching notoriety, the Stanton band participated in many community and civic events presenting several concerts. Seen above is a 1964 string orchestra performance at Hemming Park in Jacksonville. Below is a picture of the 1965 band as it marches down Main Street in Tallahassee, Florida, at the Governor's Inaugural Parade. This was one of three inaugural parades in which the Marching Blue Devils participated. Through the years, the band also participated in three University of Florida Homecoming Parades, and it was selected by the State Department of Education in 1966 to perform before the National Conference of College and University Education at their conference in Jacksonville, Education Is For All—a conference to demonstrate the high level of achievement available to African American students provided with equal education opportunities.

In 1964, the Stanton Blue Devil Marching Band and the Stanton Glee Club were selected to represent the State of Florida at that year's World's Fair in New York City. Above is an image of the band during a performance, under the direction of Kernaa McFarlin. Below is a photograph of the male and female Glee Club under the direction of Alpha H. Moore. This event was a significant accomplishment for both music groups and the Stanton community, as the groups represented the state with great pride.

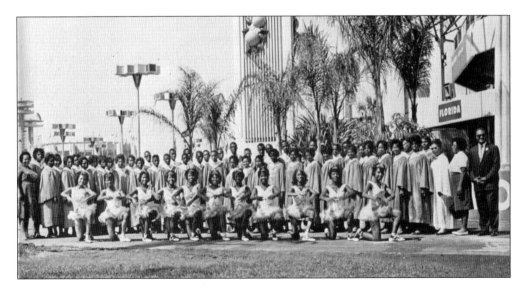

Stanton Vocational High School had an active musical program with a marching and concert band associated with its day program during the 1950s and 1960s. Featured above are the majorettes from the 1966 day program in various positions and poses. Below is a photograph of the 1969–1970 day program concert and marching band. Note their school's mascot and emblem was the "Engineers" and their colors were green and white.

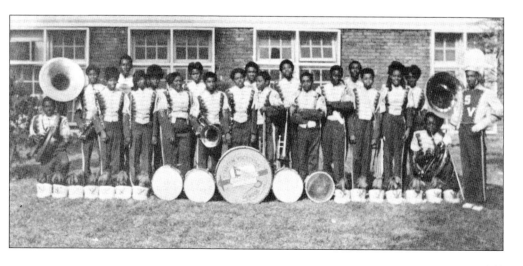

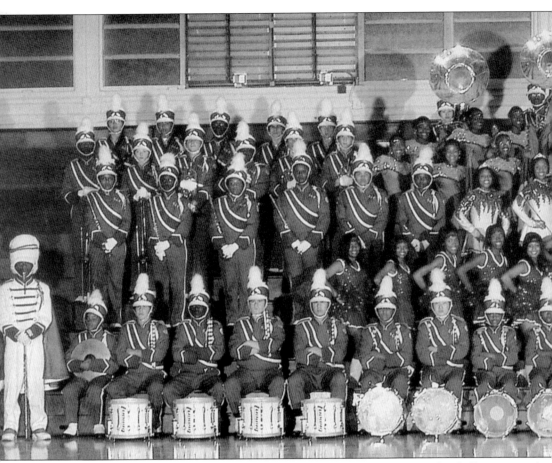

The Blue Devils Marching Band is still known as the main attraction at football games and the highlight of the pep rally. The band strives to utilize a diverse, professional performance, often incorporating modern musical performances. The band continues to participate

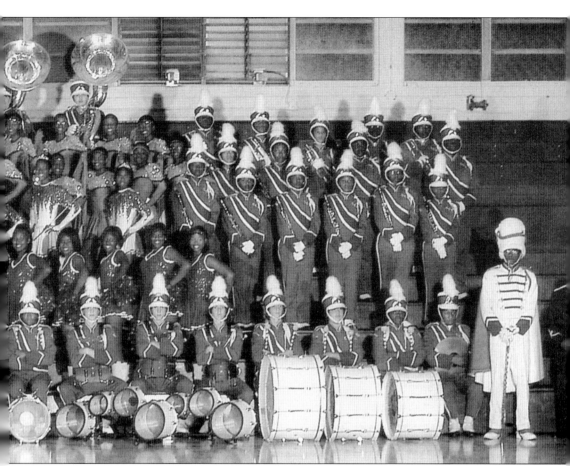

in many community events, like the Veteran's Day Parade. They also take advantage of post-season time to participate in symphonic concerts and jazz activities. This photograph features the 2006 marching band, including the dance line, flags, and majorettes.

Throughout the years, the various arts-related programs at Stanton have been considered an integral piece of the puzzle in Stanton's academic structure. Featured here is a unique combination of visual arts and the music program as a member of the 1952 majorettes is seen in action twirling her baton. The special effects used in taking this photograph make for a unique pictorial representation of this art form that combines dance and musical techniques.

Six

KEEPING THE SPIRIT ALIVE
ALUMNI ACTIVITIES

Through the years, there have been many images of the Stanton Blue Devil, the mascot for Stanton since the 1930s. Yet this slogan, coined by former faculty member and Stanton historian Thomas Crompton Jr., reflects the long-standing pride that alumni, as well as current students, have in their beloved high school, Stanton.

ALMA MATER

DEAR OLD STANTON

Give your best for dear old Stanton
For the blue and white . . .
Whether games or life's endeavors,
Always bravely fight.
Stanton, Thee, thy loyal sons
To exalt we'll try;
And we'll strive, the Blue-White banner,
Ever to hold high.

Stanton days will live forever
In our memories . . .
To the treasure store of learning,
Stanton gives the keys.
Though thy walls we all must leave
Thee we'll ever love,
Honored school, thy children love thee
To the skies above.

God preserve her light . . .
May our precepts learned at Stanton,
Guide us ever right.
Out upon unbeaten pathways,
May we travel far . . .
With the light of Alma Mater
As our guiding star.

ALUMNI NOTES

Edward O. Gourdin, class of '16 is one of our most brilliant representatives. Besides being Harvard's all around star athlete, he holds the world's championship in the running broad jump. He will represent the United States in the games which will be in Europe next month. He has reflected credit not only upon himself, but upon Stanton and his race.

Lawrence Brown, an alumnus of Stanton and Boston Conservatory of Music has gained credit for himself and his school as being for many years the accompanist of Mr. Roland Hayes. He traveled with Mr. Hayes on his tour of Europe. He has won great praise for his own compositions and has a very promising future.

Miss Arabella DeCourcey, after finishing from Stanton, took a course in social work at Morehouse College, Atlanta, Georgia, and is now employed by this city in the relief department as a social worker.

Miss Helen Chaplin, class of '20 is assistant Latin teacher in the high school of Stanton, and also secretary of the Alumni Association.

Here are some class notes as they appeared in the yearbook of 1924 recording activities and accomplishments of a few selected alumni from Stanton at that time. Note the mention of Edward Gourdin from the class of 1916, a notable and accomplished athlete at that time. This page of notes demonstrates the ongoing source of pride that Stanton had taken for decades in celebrating the accomplishments of its former students.

"THE CLASS POEM OF '38"

OUR PARTING WORDS TO STANTON

By LUCILE BUTLER

We are dawning now a parting day,
That brings a sadness to our hearts
To think of those fleeting moments,
That soon shall find us all apart.

Stanton, though we shall leave you,
Your principles shall be to us a light,
When life's dark shadows shade us,
To lead our wandering feet aright

To teach us to live in sweet accord
In brotherly love and peace forever,
That life's many problems are solved,
When we as brothers live together

To teach of God, our supreme example,
As a delivered when we pray,
To teach us love for one another,
To hold our feet when going astray.

Stanton, we hate to leave you,
And often a tear bedims the eye,
But there's not a tear of sorrow shed,
That time and patience will not dry

Who shall never forget the faculty,
And shall in tears depart in sorrow,
But we trust that your instructions
Will lead us to a bright tomorrow.

We trust that they'll make men and women
By the deeds that we have done,
That they'll make our future brighter
By the lessons that we have learned.

For we want to live in harmony
With a love for all mankind
To help our toiling fellow-brother
Up the mountain as we climb.

To work by the methods that we have learned
Whatever might be to us a foe,
For we've learned that there's strength in unity,
That "Success awaits at labor's door."

So ever keep us in your memory
As life's dark path we trod,
Till we have reached our destiny;
And rest in the eternity with God.

Here is a poem written by Lucile Butler, a senior in the class of 1938 (as it appeared in the yearbook for that year). Throughout the years, students and faculty have often written such odes to memorialize their time and give honor to their experiences and pride as a Stanton student. In the 1920s and 1930s, yearbooks were full of much more creative writing than photographs because of fewer technological advances and costs related to photography.

Stanton Class Of 1939 Holds Gala 40th Year Reunion

The Stanton Class of 1939 took a stroll down memory lane the class and guest gathered recently for their 40th year reunion, at a jubilant affair held at the Jacksonville Beach Sheraton Inn.

Festivities began with a get acquainted evening and registration where class-mates greeted familiar faces, as hugs and kisses were exchanged and tears shed, as old friends were once again reunited.

A banquet followed where guest dined on turkey, Yankee Pot Roast of Beef, and Shrimp and Seafood Newburg.

The banquet featured Mr. George S. Wiggins, reunion president, and Mr. Capers M. Thompson, treasurer, as Toastmasters.

The invocation was delivered by Mr. Frank Cooper and a memorial was given by Mr. John G. Davis on behalf of all deceased class members. Mrs. Bessie Adair Washington, Miss Stanton of 1939, rendered a beautiful solo.

The highlight of the evening was a slide presentation entitled "The Way We Were", as class-presented to Mrs. Amy S. Curry the only surviving class sponsor. Other presentation were made to Mrs. Juanita Calhoun Flynn, Mrs. Olivia McClain Flynn, and Mr. Jerome McIntosh, class members who traveled the longest distances to the reunion; over 3,000 miles from California.

Mrs. Verdell Battle Jackson, Mrs. Marion T. Sneed, and Mr. Lloyd Pearson, were cited for having been married the longest length of time—40 years, 39 years, and 38 years, respectively.

Mrs. Cora Lesesne Walton received an award as the class member with the most children, and Mrs. Alice Hagans Walton, was awarded for having the most grandchildren.

These ceramic awards were made by Mrs. Sneed, and Mrs. Flossie Hopkins Brunson. Anouncements were made by Mrs. Janie Johnson Thomas, vice-president, and the 1939 class members present were introduced by Mr. Alonza F. Lewis, and Mr. Lloyd N. Pearson, Jr.

The singing of the class

Holland Little. Rev. Albert J. Reddick, also a class member, closed the banquet by asking God's blessings on the class members and their guests.

Following the banquet, class members and guests danced to the tunes of the past and present by music rendered by Jazzco, Inc., led by Charles Scantling.

The class also participated in a Saturday picnic at Hanna Park, and a game night at the Sheraton. Sunday found the class members and their guests worshipping with class-mate Rev. Reddick, minister of Mt. Zion A.M.E. Church, and his congregation.

"We felt most cordially received by Rev. Reddick. We are thankful to God for having led us thus far," said members of the class.

Mrs. Bessie Adair Washington, and Mrs. Elizabeth Moody Keatts were asked to warm class member's hearts with musical selections.

At the close of the three day reunion, all members departed vowing to keep in touch—and were grateful to God for the fellowship and the memories.

Miss Mildred L. Carr
Mr. Charles N. Coleman
Mr. Frank Cooper
Mrs. Sarah Young Cruse
Mr. John G. Davis
Mrs. Lillie Courtney Dorsey
Mr. James D. Dyson Jr.
Mr. Samuel W. Faine
Mrs. Bernice Cooper Faulk
Mrs. Eunice Feacher
Mr. Theodore W. Frazier
Mrs. Juanita Calhoun Flynn
Mrs. Emma Speed Hall
Mr. Thomas E. Hall
Mrs. Beatrice Lewis Hammond
Mrs. Cleasie Wardell Hickson
Miss Dena M. Hutchins
Mrs. Verdell Battles Jackson
Mrs. Eunice Christopher Jenkins
Mrs. Johnnie Jenkins
Mrs. Anna Williams Johnson
Mrs. Rosetta Hierrezuelo Johnson
Mrs. Florence Williams Kato
Elizabeth Moody Keatts
Mrs. Mildred Stafford Kershaw
Mrs. Alice McCoy Lake
Mrs. Irma Sharpe Lawrence
Mrs. Queen Holland Little
Mrs. Leonora Daniel Lee
Mr. Alonza F. Lewis

Mrs. Mary Brown Pete
Dr. Larney G. Rackley
Rev. Albert J. Reddick
Miss Lula Mae Roundtree
Mr. Emeritt S. Sneed
Mrs. Marion Tyrus Sneed
Mrs. Daisy Baker Stinson
Mr. William S. Surcey
Mrs. Alice Hagan Thomas
Mrs. Agnes Albertie Brown
Mrs. Olivia McClain Thomas
Mr. Capers M. Thompson
Mrs. Camilla Perkins Thompson
Mr. Sanuel R. Walker
Mrs. Cora Lesene Walton
Mrs. Bessie Adair Washington
Mr. Alphonso West
Mr. George S. Wiggins
Mrs. Arey Chrispen Williams
Mrs. Juanita Wesley Williams
Mrs. Mattie Crump Williams
Mrs. Reponza Lang Williams
Mrs. Rosa Mae Gadson Williams
Mrs. Janie Johnson Thomas
Mrs. Rosetta Hierirzulolo Johnson

PRESIDENT

NOMINATES

Stanton has an active alumni network that regularly celebrates in reunions. Many class years gather regularly for meetings and get-togethers beyond significant yearly reunion events. Pictured above is a news article on the 40-year reunion celebration for the Stanton class of 1939 in 1979. The image features details on the reunion dinner, held at the Jacksonville Beach Sheraton Inn. Below is a photograph from that event with various members from the class of 1939.

118

Pictured here are two more examples of significant class reunions that illustrate the longevity of connections Stanton students have with their school and former classmates. Above is a photograph taken in 1982 at the 40th reunion for the class of 1942. Below is a photograph taken in 2003 of the class of 1933 as they celebrated their 70th reunion at American Beach. In this photograph are 12 of the 19 remaining members of the class along with one of their teachers, Cora Ross, age 97 (far right). Their previous reunion meeting was in 1998. Big topics of conversation were remembering their alma mater and the many changes in the world in the seven decades since they had graduated.

Stanton Vocational
Alma Mater

Love you Dear because we met you
And we'll try to be
Loyal Sons and Daughters to you
Till Eternity.
Lift your voices, hail its glory
To its name be true
In our hearts we'll always treasure
Memories of you.

From your bounty we have gained
Skill of hand and mind
And we pledge to dedicate our
Lives to all mankind.
Only time can tell the story
Of our hope in thee
Only hope can spur us onward
To our victory.

Let the Green and White keep waving
O'er your walls so proud
And with Grace and Perseverance
May you be endowed
Alma Mater, Alma Mater
How we honor thee,
And we'll strive to bear your banner
Till Eternity.

These photographs feature Ruby Lee Frazier Pough, who is a proud alumnus and former assistant head majorette of the Marching Stanton Vocational Engineers, led by band director Charles T. Maxwell. Pough was attracted to Stanton Vocational, or "VO" as it was called by former students, because of its nursing program but later elected tailoring, which afforded her the opportunity to matriculate into Florida Junior College, where she later became a licensed medical technician. Her memories of "VO" are numerous because of the close relationships between classmates and the experiences she shared with her instructors, who provided her with proficiency as well as role-modeling for her work in community service. (Both courtesy of Ruby Pough.)

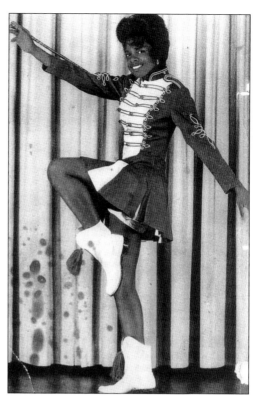

Two other proud Stanton Vocational alumni are featured here. At left is Quenthon "Nick" Malpress, who graduated from "VO" in 1962. He was heavily involved with athletics at the school during that time, extending into his current involvement as one of Jacksonville's most notable referees of local football and baseball games. Below is Alexander Williams, who graduated from Stanton Vocational in 1969. He warmly remembers his days under Principal Ben Durham at "VO," reflecting on the times when Principal Durham would personally retrieve him from the local pool room on Jefferson and Ashley Streets to return him to classes. (Left courtesy of Nick Malpress; below courtesy of Alexander Williams.)

These images come from the program for the Annual Gala to celebrate the faculty and students from Stanton, New Stanton, and Stanton Vocational High School. The photograph at right is a message from the gala's chairman, Kenneth W. Reddick, as he conveys his pride in Stanton and this special event that is coordinated and planned by teams of former students, as seen by the listing of committee members in the image below. The range of class years involved is commendable and illustrative of the ongoing efforts and hard work that Stanton alumni invest in celebrating the important legacy of Stanton. (Both courtesy of 2007 Annual Stanton Gala Committee.)

Message From The Chairman

*Stanton, New Stanton or Stanton Vocational, the name **Stanton** says it all. What a rich heritage since 1868! Very special thanks go out to our teachers, faculty and staff. All of them touched our lives in some way. We are today because of what they were to us then. I would like to especially thank one educator, Mrs. Ruth Cummings Solomon, for helping me build my confidence and self esteem at an earlier age. Nurturing, caring and strict discipline have made us appreciate the importance and value of a broad based education. We now see how their commitments impacted our lives. Also, living in the same neighborhoods and attending the same churches made a world of difference.*

Of the many occasions I have helped plan, this one has to rank at the top. Someone asked me in the course of our planning what event planner were we using. I told them I had a team of planners. Our planners were many of the class leaders and our schoolmates. I wanted this to be a unique evening, something special and more importantly memorable. Our committees have labored hard to make this happen. It may not be perfect but hopefully you can appreciate all the effort that was put into it to make it as near perfect as possible. While I appreciate all the encouragement and accolades, this could not have been done without the excellent cooperation and participation of so many classes. Thanks to all our committee chairpersons and volunteers.

Tonight reminds me of a "Field of Dreams", an idea turned into a reality. No one could have anticipated a dream come true quite like this. Everyone stepped up to the plate. The result is a win-win for all Stantonians. Inclusion, togetherness and oneness have made this evening a huge success. Behold, how good and how pleasant it is for brethren and sisters to dwell together in unity! Psalms 133.

I am hopeful that we will continue to have future annual galas where Stantonians can come together in fellowship with each other. We really need more help from all class leaders to get the word out to all their classmates. We don't want any class-member to not know of an event such as this.

It's been a real pleasure to serve you. Until next year, be blessed!

Kenneth W. Reddick
Gala Chairman

Stanton Gala Officers
2006-2007

Chairman	Kenneth W Reddick '63
Vice-Chairman	Clarence Von Bostick '49
Recording Secretary	Sandra Cummings Thompson '60
Corresponding Secretary	Charleyene Bloodworth Martin '65
Financial Secretary	Norma Lang Brown '54
Treasurer	Julie Newman Boulware '67
Business Manager	James Tippins '53
Chaplain	Rev Bernard Wright '64
Sergeant at Arms	Henry Newman '53
Parliamentarian	Claude Hunter '53

SUB-COMMITTEE MEMBERS

Souvenir Program
*Sandra Cummings Thompson '60
Eula Mayes '44
Norma Solomon White '51
Ruth C. Jones Taylor '69
Beverly B. Johnson '66

Public Relations
*Charleyene Bloodworth Martin '65
Rometa Graham Porter '58
Joyce Gray Smith '63
Ruth C. Jones Taylor '69
Helen Davis Bailey '64

Decorations, Banner, etc.
*Gail Walden Holley '59
Carla Lucas Whiteside '71
Rometa Graham Porter '58
Barbara A. Davis '58
Annette Bell '59

Awards/Recognition/Door Prize
*Eula Mayes '44
Letha McBride Iles '53
Annette Bell '59
Gracie Smith Forman '63
Joyce Gray Smith '63

Finance
*Julie Newman Boulware '67
Norma Lang Brown '54
Carl Johnson '66
Barbara A. Davis '58
Charlie Kennebrew, Jr '66
James Tippins '53

Entertainment
*Charlie Kennebrew, Jr '66
Sandra Cummings Thompson '60
Annette Bell '59
Gail Walden Holley '59
Rev. Bernard Wright, Jr '64
Carl Johnson '66
Henry Clemons '76

Video/Photography
*Claude Hunter '53
Kenneth Reddick '63

Tickets
*Sandra White-Manigault Jones '66
Norma Lang Brown '54

*Denotes Chairperson

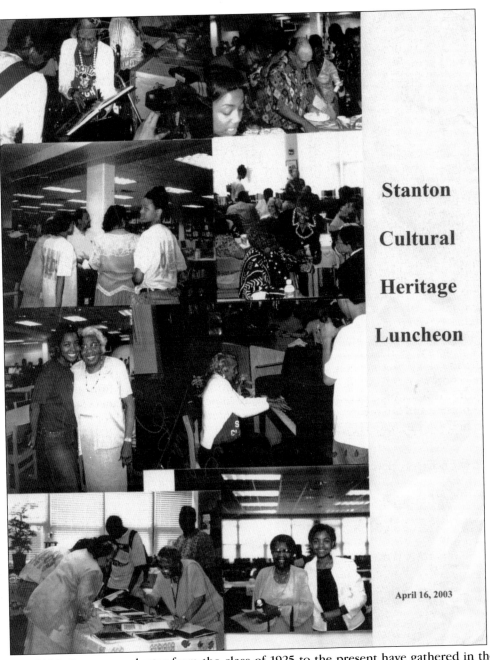

Stanton Cultural Heritage Luncheon

April 16, 2003

Since 2002, Stanton graduates from the class of 1925 to the present have gathered in the school's auditorium for an afternoon of memories, fellowship, and food at an annual luncheon sponsored by the Stanton Cultural Heritage Committee, headed by Grace Galvin. The goal of the committee is to gather, preserve, and celebrate the history of Stanton. The accomplishments of this committee and its chairperson have been recognized throughout the city of Jacksonville. Seen here is a collage of photographs from the first few luncheons, where current Stanton students can learn about their school's history from the alumni in attendance. Each year, the luncheon features a theme, as well as celebrating the oldest and most current senior class years.

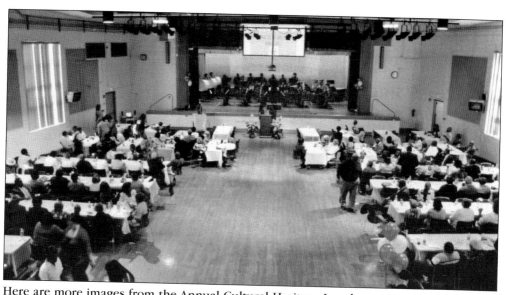

Here are more images from the Annual Cultural Heritage Luncheon. As seen in the above photograph, the school's auditorium fills up with former faculty, administrators, and graduates who participate in an event where the school's current students generously cater to the alumni, serving lunch and asking plenty of questions about their high school days. The program for the luncheon typically features various presentations, such as a "past and present" video presentation, historical poetry, drama performances, dance routines, and the school's award-winning band. A sample version of a program from one of the first luncheons is featured below. These events are important as they connect Stanton's past to the present and are highly appreciated by the wider Stanton and Jacksonville community.

"Cultural Heritage History of Old Stanton and New Stanton"

Committee Members

Chair - Mrs. Grace Galvin

Mrs. Diana Blount
Mrs. Paula Branham
Mrs. Delores Ellison
Mrs. Evelyn Galvin
Mrs. Carla Jackson
Mr. Jim Jaxon
Mr. Larry Knight
Mr. Ty Rogers
Ms. Tamala Simmons
Mrs. Verna Simmons
Mr. C.L. Smith
Mrs. Veronica Troup
Mr. Royce Turner
Mrs. Janice Waters
Mr. Marcus Young

Programme

Welcome............................Mrs. Veronica Troup

Introduction of Committee Members.........Mr. Jim Jaxon

MusicalStanton's Band, Mr. Marcus Young Directing

Luncheon and Slide Presentation

Collection of Cultural Materials.........Mrs. Grace Galvin
OLD & NEW Stanton

Introduction of Audience.................. Mr. Royce Turner
Video – Mrs. Winona Britt – Class of 1933
(A Tour of Stanton High School will follow immediately after the program)

Closing Remarks Mr. Jim Jaxon
Principal - Stanton College Preparatory School
Mr. Royce Turner
Vice Principal - Stanton College Preparatory School

The above photograph shows a sample of bricks that can currently be seen in the courtyard of Stanton. These bricks have been purchased by former and current students in support of the school as well as in remembrance of former classmates. The student's name, class year, and sometimes former affiliations are printed on the purchased bricks. This effort is sponsored by one of the active parent organizations that helps to foster the maintenance of Stanton College Preparatory School. Parents have always held an active role in the day-to-day existence of activities, events, and organizations within Stanton. Bricks and benches can be dedicated in honor of students—another legacy of Stanton's proud alumni heritage. Below is a photograph Grace Galvin—book author, Stanton alumni, current staff member, and Cultural Heritage Committee chairperson—as she proudly sits at a bench dedicated by her family for her accomplishments and commitment to Stanton.

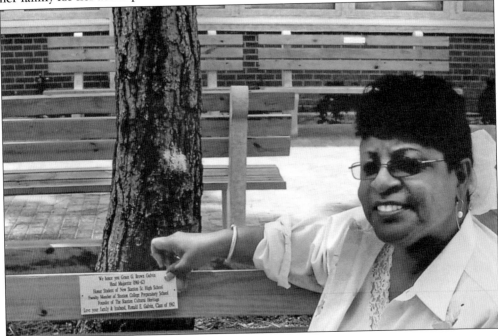

STANTON FIGHT SONG

On Blue Devils, On Blue Devils
Fight, Fight, Fight, Fight, Fight
We Will Never, Never Ever
Give Unto The Foe
On Blue Devils, On Blue Devils
Fight For Victory
We Will Always Stand Up For The
Blue And White.

ACROSS AMERICA, PEOPLE ARE DISCOVERING SOMETHING WONDERFUL. *THEIR HERITAGE.*

Arcadia Publishing is the leading local history publisher in the United States. With more than 5,000 titles in print and hundreds of new titles released every year, Arcadia has extensive specialized experience chronicling the history of communities and celebrating America's hidden stories, bringing to life the people, places, and events from the past. To discover the history of other communities across the nation, please visit:

www.arcadiapublishing.com

Customized search tools allow you to find regional history books about the town where you grew up, the cities where your friends and family live, the town where your parents met, or even that retirement spot you've been dreaming about.